capturing drama in NATURE
PHOTOGRAPHY

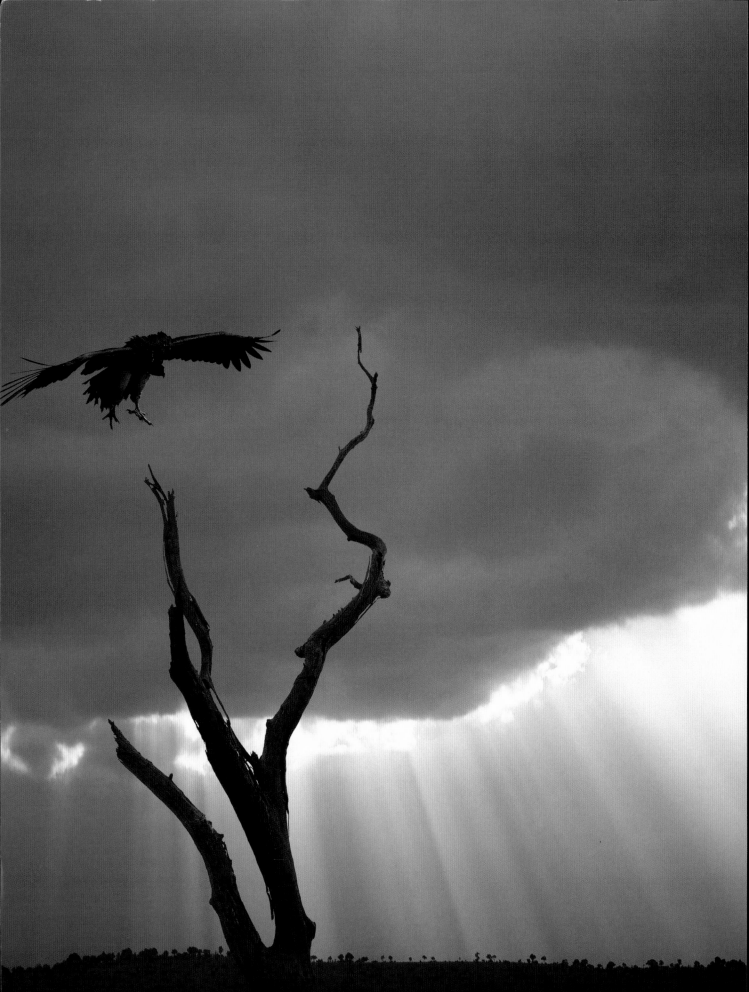

capturing drama in NATURE PHOTOGRAPHY

Jim Zuckerman

WRITER'S DIGEST BOOKS

Cincinnati, Ohio
www.writersdigest.com

CAPTURING DRAMA IN NATURE PHOTOGRAPHY. Copyright © 2000 by Jim Zuckerman. Manufactured in China. All rights reserved. No part of this book may be reproduced in any form or by any electronic or mechanical means including information storage and retrieval systems without permission in writing from the publisher, except by a reviewer, who may quote brief passages in a review. Published by Writer's Digest Books, an imprint of F&W Publications, Inc., 1507 Dana Avenue, Cincinnati, Ohio 45207. (800) 289-0963. First edition.

Other fine Writer's Digest Books are available from your local bookstore or direct from the publisher.

04 03 02 01 00 5 4 3 2 1

Library of Congress Cataloging in Publication Data

Zuckerman, Jim.
 Capturing drama in nature photography / Jim Zuckerman.
 p. cm.
 Includes index.
 ISBN 0-89879-991-0
 1. Nature photography--Handbooks, manuals, etc. I. Title.
TR721.Z82 2000 00-025816
778.9'3--dc21 CIP

Editor: Megan Lane
Production editor: Christine Doyle
Production coordinator: John Peavler
Designer: Matthew Small Gaynor
Production artist: Ruth Preston

Dedication

This book is dedicated to my nieces, Sara, Andrea, Emily, and Jamie, all of whom make me optimistic about the future of our civilization.

Acknowledgments

I am indebted to my dear friend, Claudia Adams, for sharing with me many of her special photo locations and for her loving support on many levels.

Thanks also to Imacon, Inc. of Fremont, California, for developing a superior photo scanner which is comparable to a drum scanner but at a fraction of the price. All of the pictures in this book were scanned with the Imacon FlexTight Photo scanner.

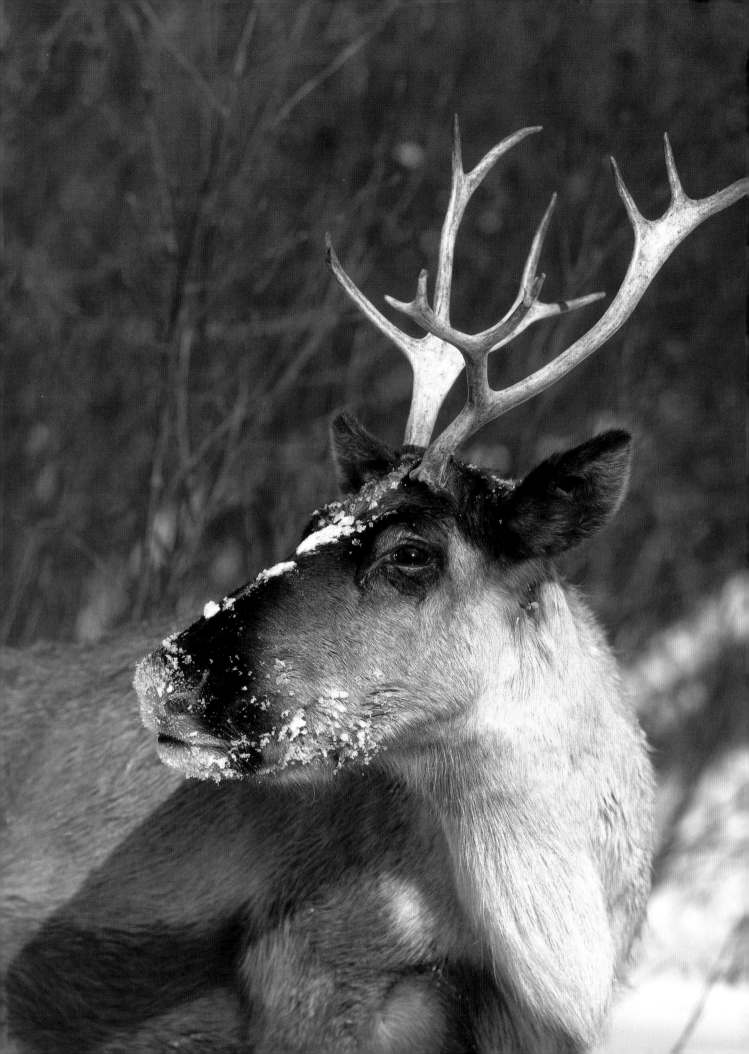

About the Author

Jim Zuckerman left his medical studies in 1970 to turn his love of photography into a career. He has taught creative photography at many universities and private schools, including the University of California at Los Angeles and Kent State University of Ohio. He has led many international photo tours to destinations such as Burma, Thailand, China, Brazil, Eastern Europe, Tahiti, Alaska, Greece, and the American Southwest.

Zuckerman specializes in wildlife and nature photography, travel photography, photo and electron microscopy, and special effects. He also applies his talents to computer manipulation, producing cutting-edge imagery that would have been impossible only a few years ago.

Zuckerman is contributing editor to *Peterson's Photographic Magazine*. His images, articles, and photo features have been published in scores of books and magazines, including Time-Life books, publications of the National Geographic Society, *Outdoor Photographer, Outdoor and Travel Photographer, Omni* magazine, *Conde Nast Traveler, Science Fiction Age*, Australia's *Photo World*, and Greece's *Opticon*. He is the author of several photography books including *Jim Zuckerman's Secrets of Color Photography, Techniques of Natural Light Photography*, *Visual Impact*, and *The Professional Photographer's Guide to Shooting and Selling Nature and Wildlife Photos.*

His work has been used for packaging, advertising, and editorial layouts in thirty countries. It has also appeared in calendars, posters, greeting cards, and corporate publications. His stock photography agency, Westlight, is in Los Angeles.

You can visit Jim Zuckerman's Web site at www.jimzuckerman.com.

Contents

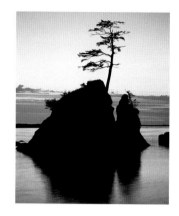

Form
CHAPTER 1
page 14

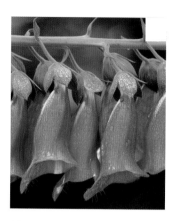

Simplicity
CHAPTER 2
page 24

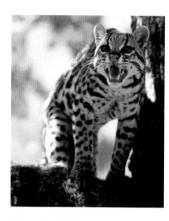

Peak Moments
CHAPTER 3
page 32

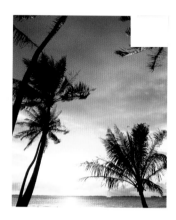

Light
CHAPTER 4
page 44

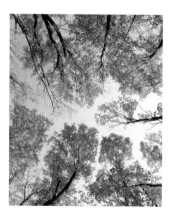

Perspective
CHAPTER 5
page 54

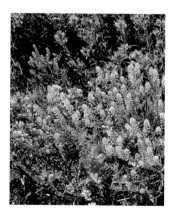

Color
CHAPTER 6
page 64

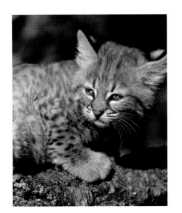

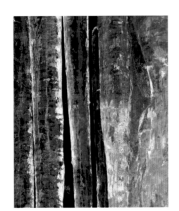
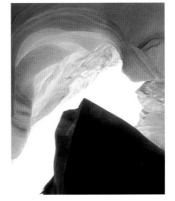
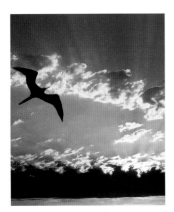
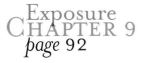

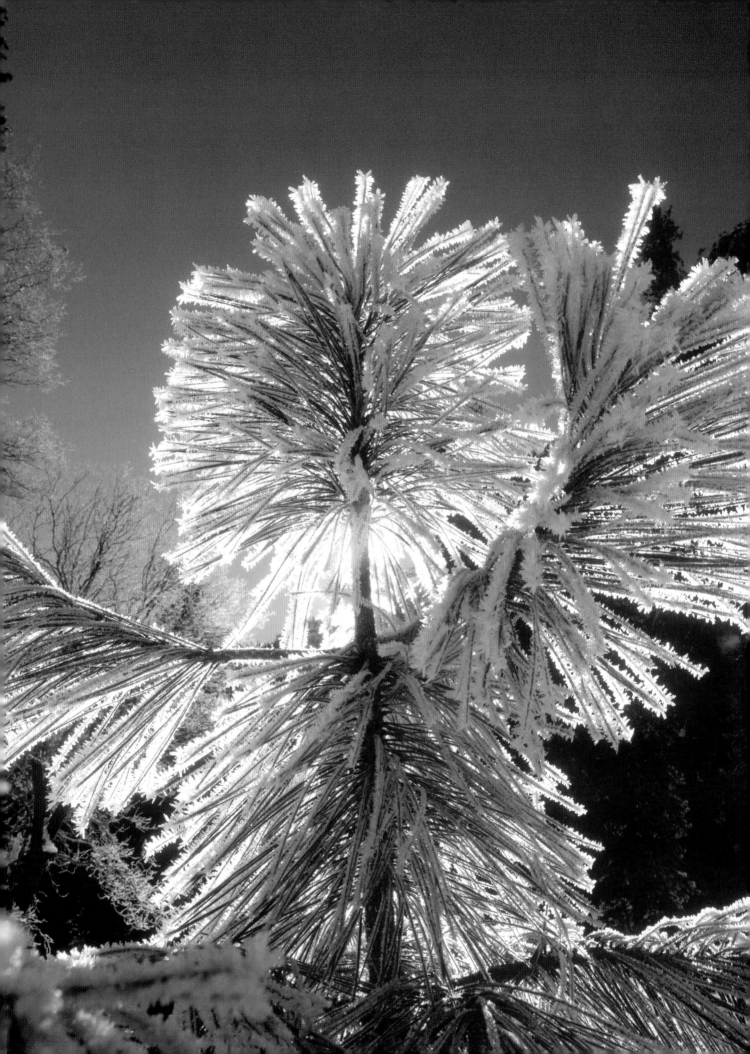

Introduction

Many professional photographers begin their careers with a love of photographing nature. Flowers and wild animals, vast landscapes, lightning storms, and raging white water all seduce our hearts and souls, and we try to compress the drama, mystery, and majesty of the natural world onto small pieces of film. Eventually, economic concerns become pressing, and many would-be nature photographers see more money in shooting commercial, fashion, or portrait assignments — and abandon their quest for the beauty of nature.

Fortunately for me and a number of other nature photographers, I followed my dream to shoot what I wanted. I could not turn my back on the joy I got from capturing special moments in nature. The experience of traveling to places of great beauty and of capturing them on film not only enriches my life profoundly, but the memory of each place and the creation of each photograph are deeply etched into my being. The mental concentration required to make excellent images somehow intensifies my memory, and when I revisit photographs in my files, even those taken many years ago, I can relive the sensations of being there as if they occurred yesterday.

This book is about seeking out and photographing the drama in nature. When imagining high drama in the natural world, one might immediately picture charging elephants, combative elephant seals, tornadoes, or thundering waterfalls. But drama can be defined with other parameters. Shocking colors in insects, birds, and flowers are also dramatic. Drama occurs in less bombastic venues as well. Micro dramas are happening all around us, if we can only bear witness to them. Caterpillars emerge from chrysalides on the undersides of leaves, exquisitely shaped snowflakes fall by the quadrillions in winter, lizards form artful silhouettes on palm fronds, and female porcupines carefully touch noses with their offspring. These examples come quickly to mind, but I could write an entire book on countless situations that are fascinating, beautiful, and ultimately dramatic.

Translating nature's drama to film requires a three-step process. First you must locate the subject. Second, you must previsualize an artful interpretation of it. This entails seeing in your mind's eye a strong composition, a unique angle, or the best lighting. And third, the technical aspects of the shoot come into play. These include exposure, critical focus, the appropriate lens, and the most advantageous film to use for a given subject.

This book is designed to address these three steps so that you can take the information and the photographic examples contained in the following pages and apply them to your image making. There are enough great images in the world waiting to be taken for everyone to take as many as they like: There's no shortage of supply. If you follow the guidelines set forth in this book, you will see an improvement in your work of which you should be very proud.

As I write books and articles on photography, I try to find the best ways to help people fulfill their potential in creating powerful and dramatic images. In this book, I've taken twelve important concepts and have, with many illustrations, shown how using these ideas can transform ordinary picture taking into something truly special.

Once you have read this book, keep a list of the chapters handy in your camera bag and refer to them frequently. While reviewing the ideas on location, you may come up with a unique picture that otherwise would have escaped your attention. I use this technique often (even though I'm the one writing the book!). There are so many ways to interpret a subject that it's easy to overlook techniques you've studied or even used in the past. For example, you may be shooting textures or looking for simplicity in nature, but you forget about using long exposures to blur the subject artistically. Many of the pictures in this book resulted from keeping a list of creative techniques in the forefront of my thinking as I shot in the field.

Equipment in the Field

I am often asked by people who take my workshops and tours what equipment they should carry into the field. My answer is always the same: Take everything. What happens, I ask, if you leave your macro gear at home, thinking you'll only be shooting landscapes, and then a gorgeous butterfly lands on a flower right in front of you? You will have missed a great opportunity. Or maybe you think you'll only be shooting wildlife with long lenses, and suddenly a double rainbow fills the sky. If you didn't bring a wide angle, the beautiful landscape shot will only be a memory instead of an image. What's the point of investing thousands of dollars in photographic equipment if you don't bring it to the beautiful places you want to shoot?

Obviously, if significant hiking is required, you must make some compromises regarding the weight and volume of gear that you can comfortably carry. On the other hand, if you are using a car as a base or are taking only a short walk to a photo location, more equipment can be managed.

There are six essential pieces of equipment that, in my opinion, must always be with you on a nature shoot: two camera bodies in good working order, a telephoto lens, a wide angle lens, a means of close focusing, a tripod (preferably with a ball head), and a cable release. A seventh item, the meter, is usually built into the body. If not, then a hand held meter must be included in this list.

The close focusing capability noted above can come from an additional lens, such as a macro lens, or your telephoto can be a telephoto macro lens. Alternatively, extension tubes, bellows, and high-quality optical diopters can be used in conjunction with a lens you are already carrying. For example, I started using the Canon 500D diopter on a medium telephoto for macro work. It looks like a thick filter and is perfect for fieldwork because it is relatively light and small.

The gear carried into the field becomes more of a debate when you start thinking about which telephoto(s) and which wide angle(s) to bring. For example, when shooting in low-light conditions, fast lenses are needed — particularly when shooting wildlife — to permit fast shutter speeds. Instead of a 300mm f/5.6 telephoto, which is small and light, a 300mm f/4 or even a 300mm f/2.8 will enable you to get pictures otherwise impossible to successfully shoot under deeply overcast skies. The price you pay, though (besides the additional dollars), is the extra weight and volume of the larger lens. My feeling is that if you put out a serious investment in an expensive lens, bring it. Otherwise, what's the point in having it?

Super long and fast telephotos such as the 400mm f/2.8 and the 600mm f/4, are in another category entirely. Most people can't, or won't, carry those monsters into the field unless they can shoot from a vehicle. This limits their use, but it's a reasonable compromise with a challenging situation.

Regarding wide angle lenses, a practical approach to landscape photography is the 24mm (in the 35mm format). However, ultrawide angle lenses are fantastic for dramatizing compositions, and 17mm to 20mm rectilinear lenses are small enough so that you can carry one easily. I would recommend you always carry such a lens with you.

A flash is another item that will often come in handy. Portable units are small and lightweight, and they can be used for macro work or for filling shadows in contrasty conditions. If you still have room in your camera bag or photo backpack, I would strongly suggest you carry one, along with extra batteries. The flash bracket I prefer holds the flash directly over the lens so there are no distracting and unnatural shadows behind the subject.

I shoot the Mamiya RZ 67 system, which is medium format. Each negative or slide I expose is 6cm x 7cm, or $2\frac{1}{4}''$ x $2\frac{3}{4}''$. I prefer the larger image area for increased resolution and for additional competitiveness in the photographic marketplace. There are significantly fewer alternatives in lens availability than in 35mm photography, however. I always carry two camera bodies and five lenses: 50mm wide angle, 110mm normal, 250mm telephoto, 350mm APO telephoto, and 500mm APO telephoto. And sometimes I add the 37mm fisheye when I've eaten an extra bowl of Wheaties for breakfast! The 500D close-focusing diopter is now my macro capability of choice, and the flash I carry is the Metz 45 CT-2. I also carry a polarizing filter and a graduated neutral-density filter for darkening bright skies in certain situations. My tripod is a light carbon fiber Gitzo with an Arca Swiss ball head.

There are a number of specialized pieces of equipment that make life a lot easier if you can manage the extra weight and volume. These include a door-mounted tripod head, which is ideal for shooting from the car; a finely geared tripod head assembly, which allows the camera to move back and forth for critical macro work; a fresnel lens for focusing a beam of light from a flash; lens hoods; lens cleaning supplies; reflectors and diffusers; and a 1.4x telephoto extender.

Under severe weather conditions, it is tempting to carry less equipment. Trudging through the snow with a full camera backpack isn't easy. But what happens if you need a particular lens and that's the one left behind to lighten your load? That's why I carry all of my gear with me in virtually all circumstances — I hate to miss great shots.

form

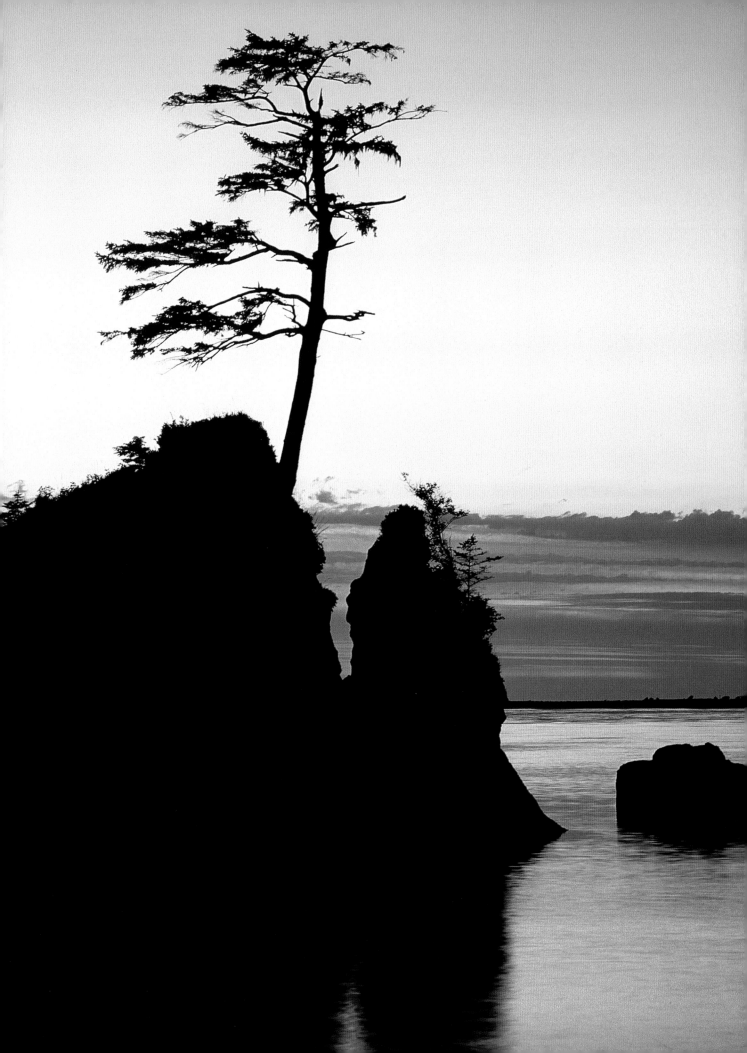

Introduction

One of the two most important contributors to dramatic photographs is form (the other is lighting). The artistry of any image is directly dependent on the shape and graphic design of the elements that comprise the composition. This doesn't mean that a photo with poor form can't be great: Sometimes the emotional impact of a situation — or even the shock value — can suffice. But if those same pictures are also graced with beautiful form, they will be that much more striking.

Nature photographers spend most of their time looking for beautiful forms. Whether in pursuit of a stunning landscape, an intimate macro shot, a nesting bird, or a silhouette against the sun, the goal is to find that artistic graphic shape that will produce a classic image. Even when I drive along highways and back country roads, I am always looking for beautiful forms in nature. Many of my favorite photographs have been made by being vigilant in this way.

Striking graphic forms in nature are plentiful, but finding them requires much diligence. All trees, for example, are not created equally. Some offer stunning forms; others are a tangle of branches that form a compositional mess. Some trees are situated on ridges where a setting sun provides a dramatic silhouette. Most trees grow in locations that make it impossible to produce a strong image. The same applies to all aspects of nature. Some mountain ranges have awesome forms, like the Grand Tetons in Wyoming, while others are boring. Some animals have remarkable shapes, but others do not.

Animals that don't offer such graphic forms can make dramatic photographs, but the contributing factors to the success of the image must be something other than their shape. Body language, lighting, aggression, mating, or humor can come into play.

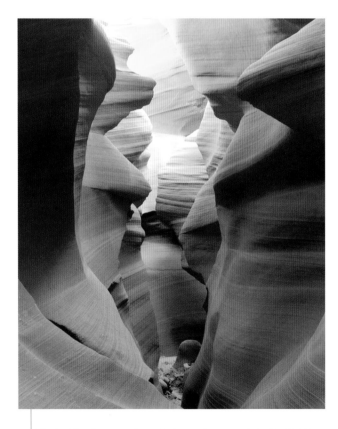

Most of the time a nature photographer spends in the field is devoted to looking for strong forms and compositions in rock formations, trees, mountain ridges, and everything else in the natural world. It takes a great deal of time, and often money, to find dramatic subjects. But the rewards are worth the effort. This shot was taken in Lower Antelope Canyon near Page, Arizona.

Mamiya RZ 67, 110mm normal lens, 4 seconds, f/22, Fujichrome Velvia, tripod.

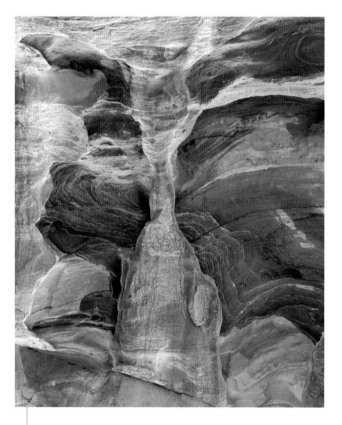

Not all rock formations are created equally. Some are exceptional in their artistry, but most are nondescript and boring. It is our job as photographers to seek out those special forms that make beautiful images. Don't waste your film on designs in nature that are less than outstanding. This design was photographed in the Wadi Araba mountains of Jordan.

Mamiya RZ 67, 350mm telephoto, 1 second, f/22, Fujichrome Velvia, tripod.

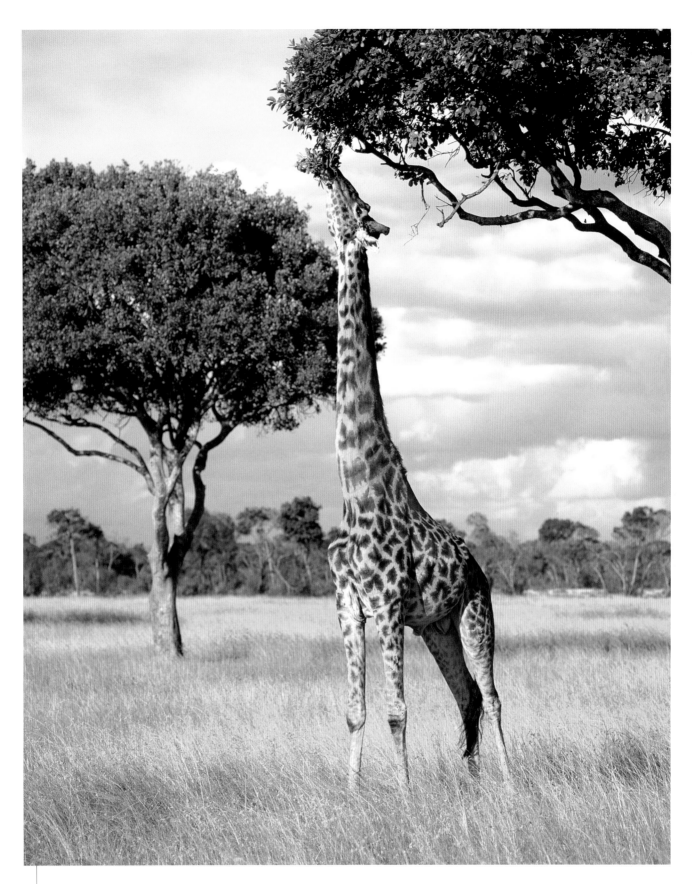

The elegant lines created by the elongated neck on this giraffe in Kenya make this picture work. Had I taken the picture while the animal was simply looking at the camera it would have been a nice shot, but it would lack the exquisite form I captured here.

Mamiya RZ 67, 250mm telephoto lens, 1/125, f/8, Fujichrome Provia 100, camera rested on a beanbag in a Land Rover.

Lens Choice

Telephoto lenses compress elements in a composition; wide angle lenses elongate them. Both types of lenses will give you dramatic form, but they do so differently. Long lenses are excellent for isolating subjects like mountain ridges, designs in a leaf, silhouettes, and patterns. Telephotos characteristically produce out-of-focus backgrounds and offer very shallow depth of field.

Wide angles, on the other hand, are unique in their perspective when used close to the subject to emphasize its size or complex graphic shape, or to show a subject in relation to its environment. Wide angle lenses have pronounced depth of field.

I use a normal lens only on rare occasions. Normal lenses are advantageous because they are relatively inexpensive, fast, and light, and the viewing is very bright. They are ideal in low-light situations and good for macro photography. But normal lenses don't offer the same ability to capture graphic forms in nature offered by the other lenses. Don't limit yourself by using only a normal lens. Simply by using a 200mm or longer telephoto, or a 24mm or shorter wide angle (in the 35mm format), you will vastly improve your photography.

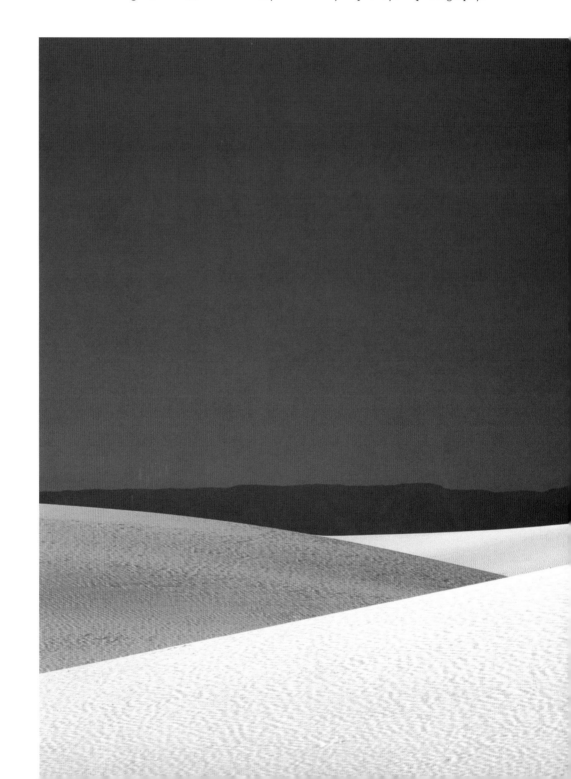

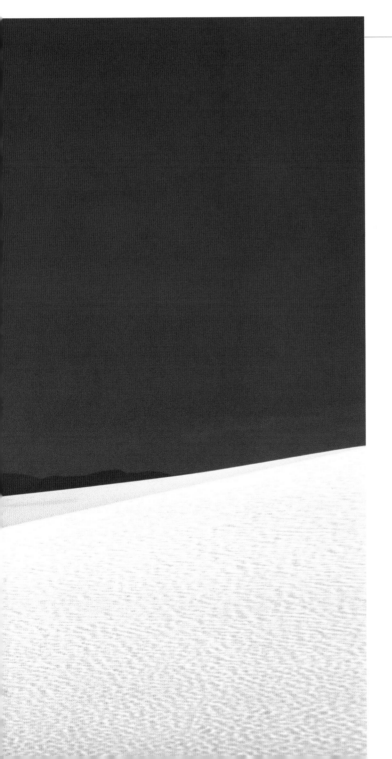

Certain elements in nature can, when isolated from the whole, create shapes and colors that have little to do with the place itself, producing an image that is simply a beautiful or unique form. The contours of the gypsum dunes at White Sands National Monument in New Mexico are an example. Standing at the site, I could see for miles in any direction. My vista included vegetation, a road, endless dunes, footprints, and the sky. Using a telephoto lens, I isolated only a small portion of the whole scene to create an image solely of form.

Mamiya RZ 67, 500mm APO telephoto, 1/125, f/11, Fujichrome Velvia, tripod.

Weather Conditions

The weather plays an important role in helping to define the form of your images. Sunrise and sunset, for example, are exemplified by long shadows, sharply defined highlights and shadows, and a beautiful mix of colors. The lines created by light against dark and by one color juxtaposed with another are form itself. For example, long shadows of trees on snow created by a low sun result in a graphic image of light against dark.

Similarly, when the sky is overcast and the ambient light is diffused, those sharp lines created with a low sun are absent. Instead, all that is left are the land forms, devoid of highlights and shadows. In these instances, the contours of rocks, the pattern of branches, the design in the petals of a flower, and the body language of an animal define the entire form of the photograph.

In fog and low clouds, natural form is muted to the point of hardly being defined at all. A sharply defined mountain seen through fog has a graphic form that is subtle and sometimes ethereal. The same is true for tree branches: In silhouette against a setting sun, the branches are bold and dramatic. In dense fog, the same tree can be muted to such a degree that it seems like a dream.

Compared to the other examples of form I have used in this chapter, a whiteout in Monument Valley during a winter snowstorm is unique. Instead of bold lines and graphic shapes, the form in this image is infinitely subtle. The graceful curvature of the foreground tree really defines the form in this shot, but the shroud of dense fog and falling snow softens the contours of what would otherwise have been a very powerful and dominating form.

Mamiya RZ 67 II, 50mm wide angle lens, 1 second, f/32, Fujichrome Velvia, tripod.

Weather conditions can change very quickly in the early morning. Overnight, low-lying fog and mist often condense in cold air, and then with the warmth of a rising sun they burn off, leaving the air clear. If the temperature at night is extreme, it can produce spectacular photographic opportunities.

🌿 *Mamiya RZ 67, 180mm wide angle, 1/125, f/8, Fujichrome Velvia, tripod.*

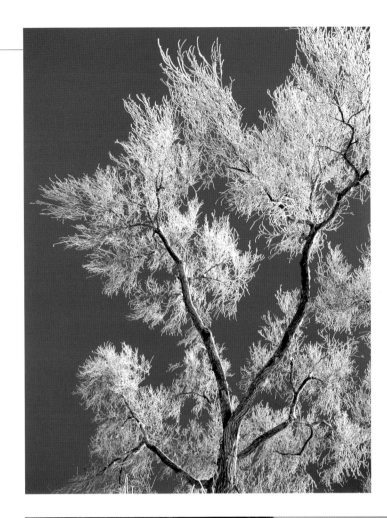

Light helps to define form because highlights and shadows actually create it. The demarcation where light becomes dark is an element that adds to or subtracts from the original subject, thereby creating a new form. The severe angle of the sun as it strikes the underside of Mesa Arch in Canyonlands lasts only a very few minutes. Sometimes only ten or fifteen seconds can mean the difference between getting the perfect lighting and missing it.

🌿 *Mamiya RZ 67, 50mm wide angle lens, 1/2, f/32, Fujichrome Velvia, tripod.*

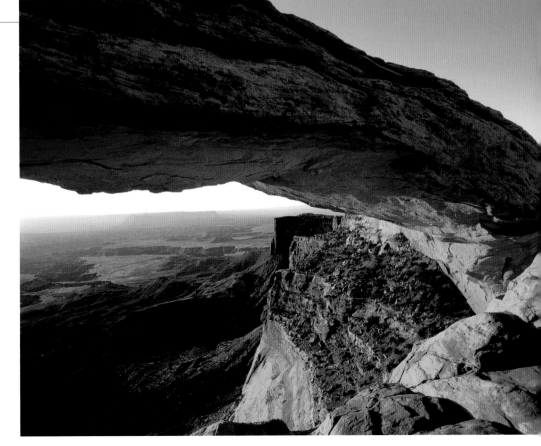

Perspective

The perspective from which you view a subject should not be static. If you can walk around the subject, look at it from all points of view. Take your camera off its tripod and study the subject without the burden of carrying a lot of gear. Move farther away. Move from side to side. Sometimes from one perspective it is exquisite, yet from another the form is totally lost. Think of an elephant. In silhouette, it is really only dramatic — and recognizable — from the side. A frontal shot against the sun would look like a big black blob.

If the subject is an animal and it is moving while your position is fixed, pay attention to every turn of the body, every swish of the tail. The form you suddenly recognize as a great shot may only last a brief moment.

Try unusual perspectives. Shoot from a high point downward. Remarkable formations can be seen from an airplane or a mountain top looking down into a valley. Leaves and flowers that have photogenic forms can be arranged on the ground below your camera's lens. Shoot straight upward as well. Fall foliage against a blue sky is dynamic, as are cave interiors. This type of perspective can produce very interesting graphic designs.

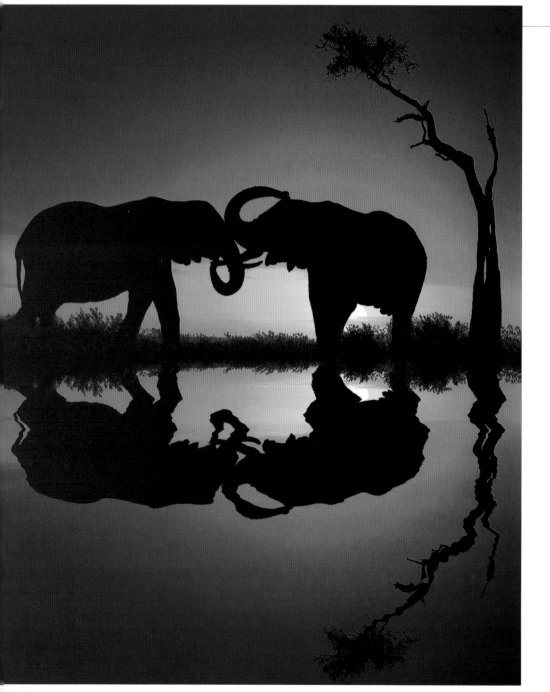

Form is nowhere more dramatized than when it is seen and photographed as a silhouette against a light and colorful background. Twice each day, at sunrise and sunset, you have the opportunity to find stunning shapes and create a memorable silhouette. Tree branches and mountain ridges are probably the easiest forms to identify, but there are many others. Among the most exciting are the forms of animals captured against a dramatic sky.

Mamiya RZ 67, 350mm APO telephoto, 1/60, f/4.5, Fujichrome Provia 100, Cokin sunset filter, camera rested on a beanbag in a Land Rover.

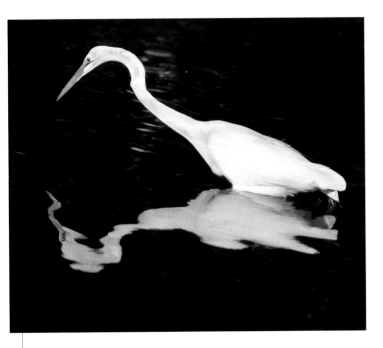

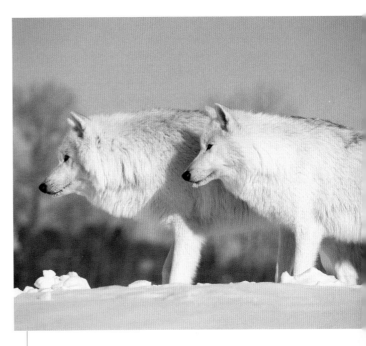

Many of the most elegant photographs consist solely of very simple lines. When form is reduced to its basic level, the truism "less is more" becomes obvious. This egret was photographed in Ding Darling Wildlife Refuge in Florida. The image is especially powerful because the form of the bird is dramatized by the contrast, the body language, and the tight composition.

❧ *Mamiya RZ 67, 500mm APO telephoto, 1/250, f/8–f/11, Fujichrome Provia 100, tripod.*

The relative position of several elements in a composition can also constitute beautiful form. These Arctic wolves photographed in -45° weather look like they were arranged for a portrait, but they held this pose for only an instant. I only had time to focus and get off one shot before this classic image was gone.

❧ *Mamiya RZ 67 II, 350mm APO telephoto, 1/250, f/8, Fujichrome Provia 100, tripod.*

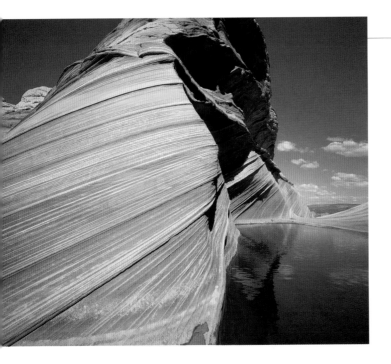

Exquisite forms in nature don't often present themselves to you without a lot of effort on your part. They are usually hiding in places that require considerable effort to see. I discovered this remarkable place in southern Utah after walking many miles from where I had parked my car on a lonely dirt road. As soon as I was in its midst, I knew this was one of the most beautiful formations of sandstone I'd ever seen. For my point of view in this composition I chose a camera position only inches from one of the cliff faces. Using a wide angle lens, I could exaggerate the perspective and give added prominence to the foreground by suggesting it was bigger than it appeared to the unaided eye.

❧ *Mamiya RZ 67, 43mm wide angle lens, 1/8, f/8, Fujichrome Velvia, tripod.*

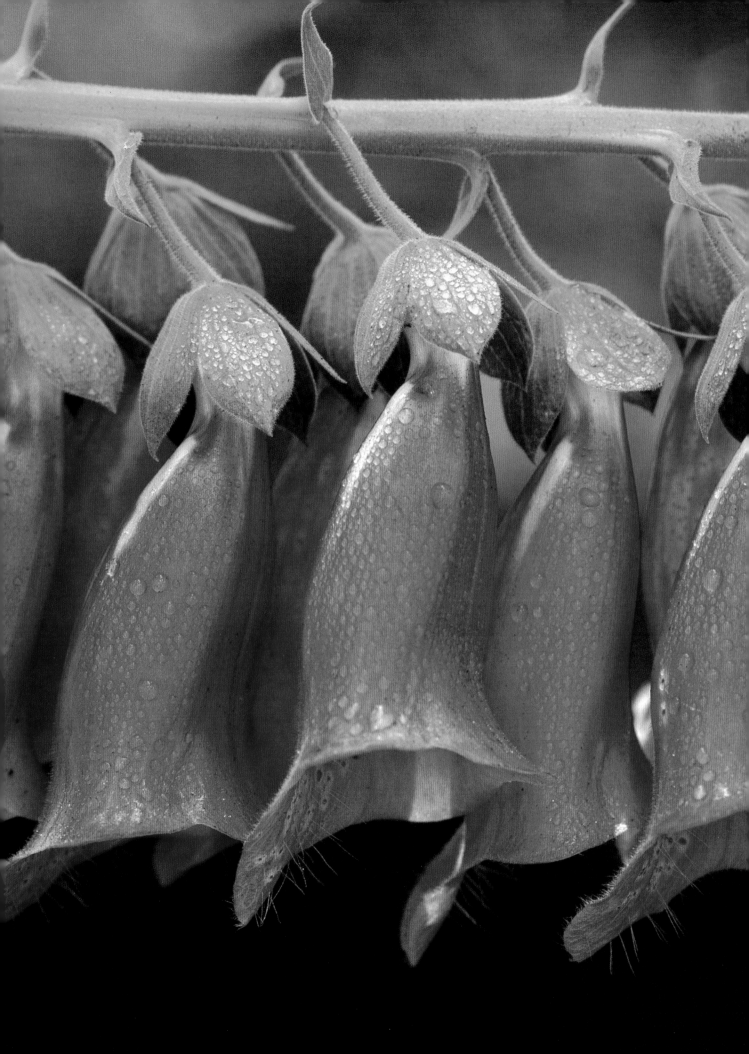

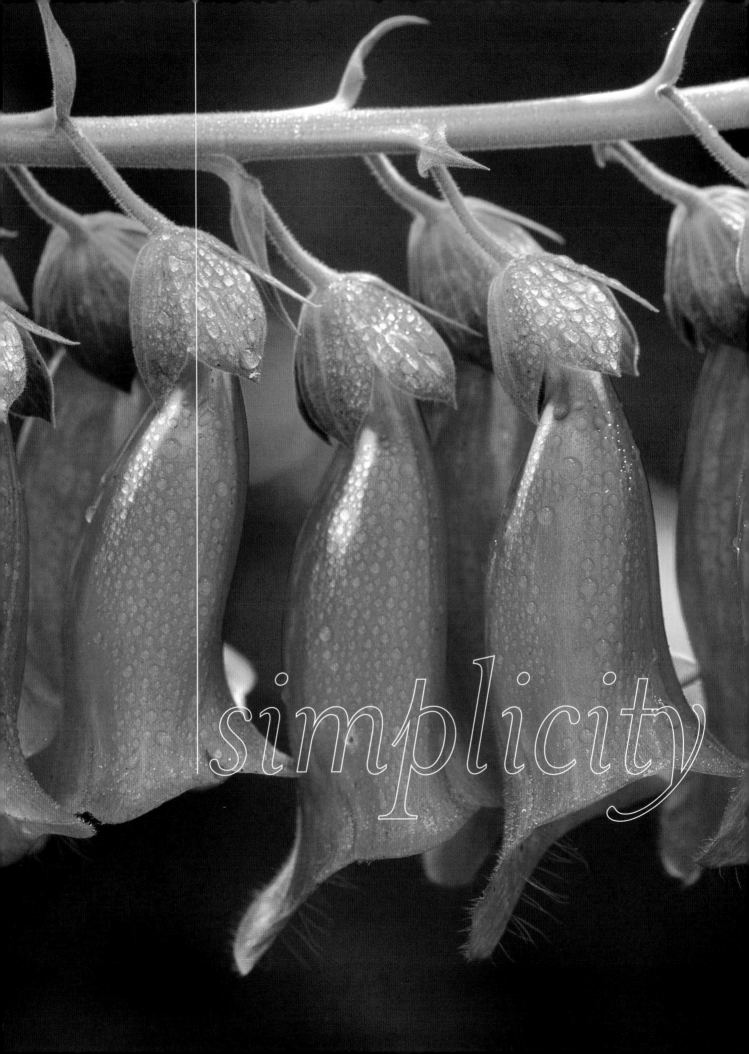

simplicity

Introduction

The most powerful images are often the most simple ones. Simplicity underscores beauty in nature in a way that busy compositions don't. When I'm in the field and I study land forms, macro details, or wildlife with a critical eye, my first thought is to find subjects that I can isolate from the whole. I always look for the simplest design elements possible.

Examples of simplicity in nature abound. Even when a complex set of elements is before you, the right lens and a sense of artistry can turn a compositional mess into a simple, elegant statement. For example, a forest is anything but simple. With a macro lens, though, you can isolate the curvature of a leaf, water drops on lichen, a bark pattern, or an intimate group of mushrooms. Similarly, a herd of caribou can present a complex set of components, but with a long lens you can isolate only the graphic form of one of the animals on a ridge.

Simplicity involves two important aspects. First, the subject must consist of no more than a few graphic shapes. Second, the background must not be intrusive. Out-of-focus backgrounds and solid backgrounds work best.

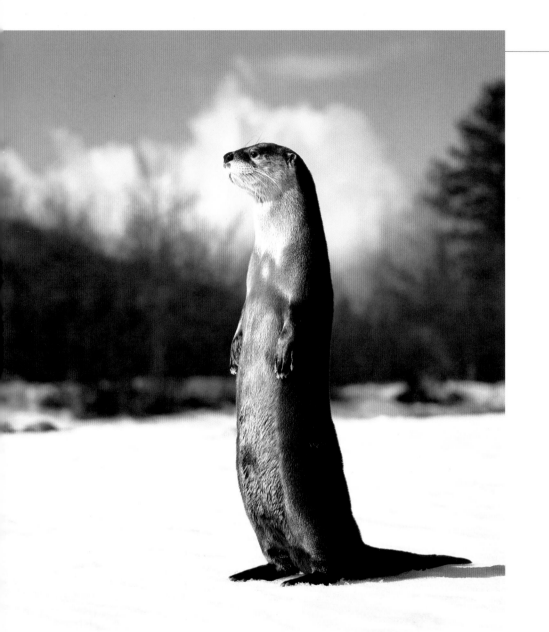

Photographic simplicity usually involves only one subject and, therefore, one point of focus. When all of a viewer's attention is centered on one thing, the impact of the subject is much greater than if other elements in the composition simultaneously compete for attention. This river otter I photographed in Montana frequently stood erect to scout for enemies. Lying on the snow and composing the shot with a long lens gave me the perfect perspective for creating a composition with a single subject.

Mamiya RZ 67 II, 350mm APO telephoto, 1/125, f/8, Fujichrome Provia 100, tripod. The tripod's legs were spread almost parallel with the ground.

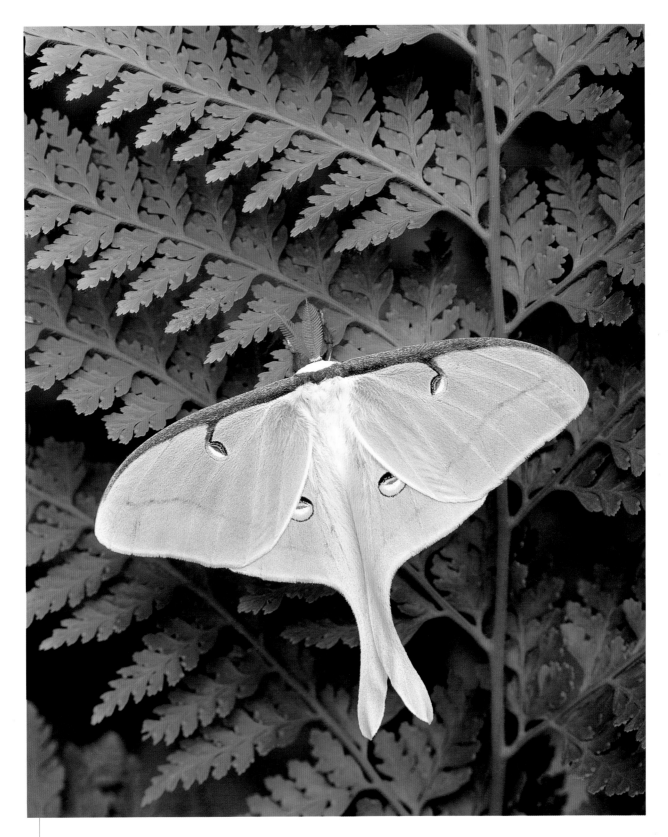

What you eliminate from a composition is just as important as what is included within the frame. Just outside the edges of this picture of a luna moth there was a messy tangle of twigs on the left side, while on the right side two or three brown leaves had fallen on the fern. Had I moved back a couple of feet and included either of these things in the photograph, the impact of the image would have been seriously degraded. Its simplicity would have been compromised, and the drama would have been lost.

Mamiya RZ 67 II, 250mm telephoto lens, 500D close-up Canon diopter, 1/4, f/32, Fujichrome Provia 100, tripod.

Composition

Composition defines simplicity in nature photography through the selection process. By choosing what to include and exclude in the frame, you can produce something simple and elegant or you can compose a confusing mess. The latter always ends up in the trash.

The rules of composition are very useful: the rule of thirds, leading lines, 'S' curves, a center of interest, and "power points" (the intersection of the horizontal and vertical lines which divide the frame into thirds). But these rules can also be broken to achieve stunning results. Some pictures are fine without a central point of interest, for example. And the rule of thirds, which suggests that important elements in the frame be placed approximately on either a horizontal or vertical third in the frame, doesn't always apply. In fact, I've placed a simple subject smack in the middle of my picture, and it works beautifully.

Sometimes the focal point can be small in proportion to the whole. Negative space, in other words, is a compositional technique used to make a powerful visual statement. A large expanse of sky, snow, or water can be juxtaposed with a small graphic subject to produce an image of simplicity with impact.

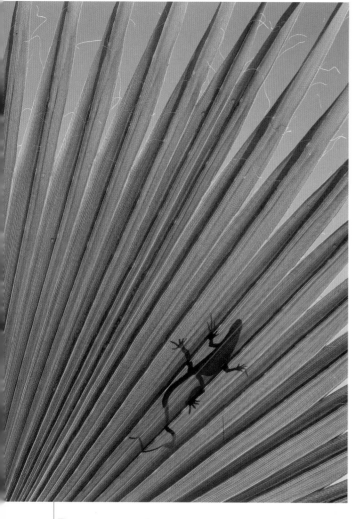 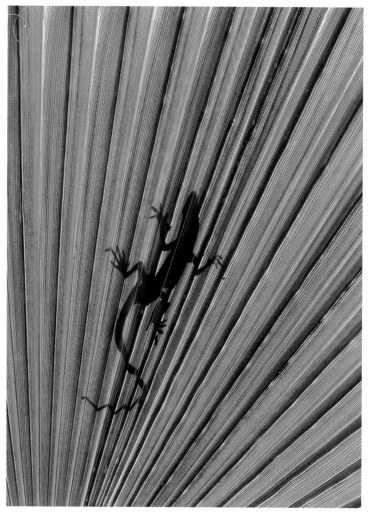

The two versions of the lizard pictured here, one including the sky and the other a tighter close-up, both underscore the simplicity of the subject — a mere shadow. Including the rich blue sky doesn't really make the picture more complicated, but it does add another element that takes a little of the attention away from the lizard. I actually like both images equally.

Mamiya RZ 67 II, 110mm normal lens, 1/30, f/22, Fujichrome Velvia, tripod.

Simplicity in nature
photography can be
achieved with the use of
negative space. In com-
positional terms, negative
space refers to large
open areas in a frame
that consist of little in the
way of form or graphics.
When a simple subject
with a dynamic graphic
shape is included, particu-
larly when it is relatively
small compared to the
negative space, the com-
bination often produces a
stunning image.

🌿 *Mamiya RZ 67, 250mm
telephoto, 1/250, f/4.5,
Fujichrome Provia 100
pushed one f/stop in
development, tripod.*

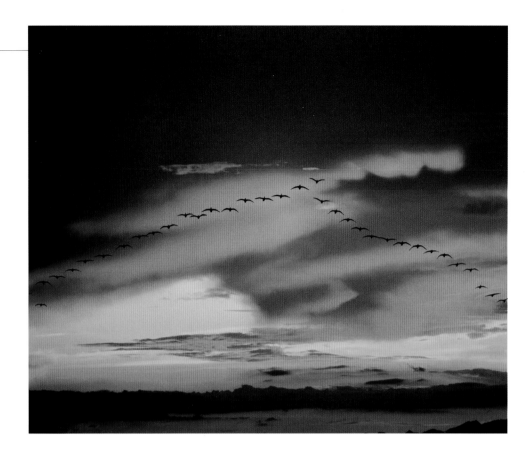

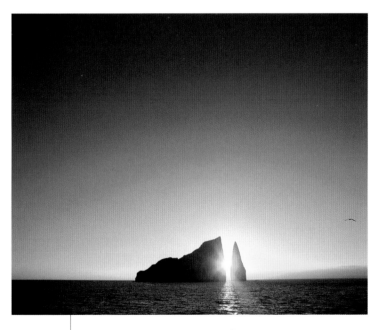

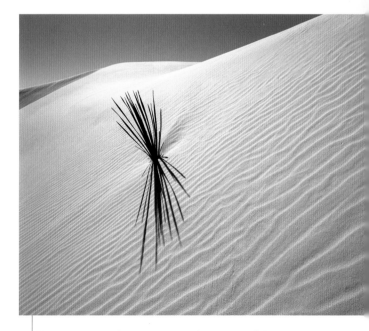

This photo of Kicker Rock in the Galapagos Islands is yet
another example of the use of negative space to create a
dramatic image of simplicity. I used a 50mm wide angle lens
to reduce the huge monolith to a small portion of the compo-
sition relative to the sky. By placing the horizon and the rock
close to the bottom of the frame, the monolith, although very
large, is reduced to a tiny structure relative to the endless
expanse of ocean and sky.

🌿 *Mamiya RZ 67 II, 50mm wide angle lens, 1/125, f/4.5, Fujichrome
Velvia, hand held.*

This image is similar in concept to the picture of the geese
formation at sunset in that negative space is used as a
counterpoint to a strong graphic image. The yucca and its
bold shadow are virtually framed by the expanse of white
gypsum sand and blue sky at White Sands National
Monument in New Mexico.

🌿 *Mamiya RZ 67 II, 50mm wide angle lens, 1/15, f/22–f/32,
Fujichrome Velvia, tripod.*

Depth of Field

Manipulation of depth of field can determine whether an image is complex or simple. Soft, out-of-focus backgrounds behind any natural object force all the attention onto that object. Our eyes cannot do this, but photographic lenses have the ability to isolate an element with the contrast of sharp versus soft to produce an image of simplicity.

One of the tools available to photographers for small subjects is the telephoto macro lens. Close-up photography is characterized by shallow depth of field, but there are differences among the various macro lenses. In the 35mm format, a 50mm macro lens will give you out-of-focus backgrounds, a 100mm macro lens will render backgrounds significantly softer, and a 200mm macro lens is even more effective at isolating a subject against its background. Subjects such as flowers, insects, leaves, icicles, and other small objects will "pop" right out of the background with a 200mm macro.

Longer macro lenses also permit a greater working distance from the subject. Rather than positioning the camera only inches away, with a 200mm macro you may be shooting from three to five feet from the subject. This means that your shadow and the camera's shadow won't interfere with your exposure. It also gives you more flexibility in choosing a camera angle.

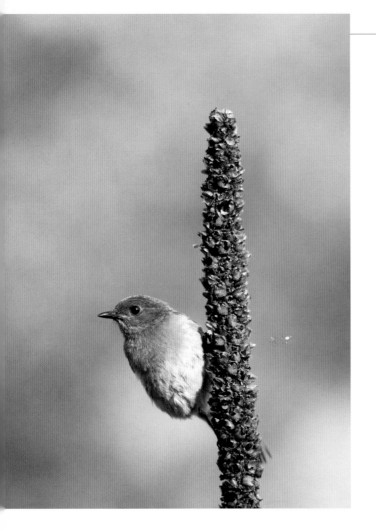

The concept of simplicity in art sometimes means that a single subject is isolated from its environment so our focus, as viewers, centers on that subject. One of the techniques you can use to achieve this is to render the background so out of focus that it is unrecognizable. In fact, it simply becomes a soft blur of color. Thus, the in-focus subject stands alone, with no competition for attention.

Mamiya RZ 67 II, 500mm APO telephoto, #2 extension tube, 1/125, f/6, Fujichrome Provia 100, tripod.

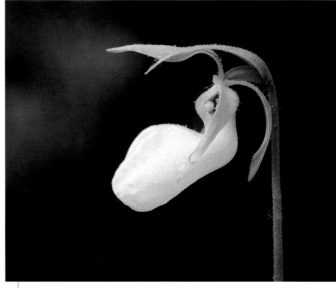

The simplicity of this white lady slipper is underscored by its isolation from the forest environment in which I found it in Michigan. To achieve this, I used a technique reserved only for certain situations: I placed a 16x20 print of out-of-focus foliage behind the flower, allowing me to use a small lens aperture to achieve a greater depth of field on the flower while leaving the background completely soft.

Mamiya RZ 67 II, 250mm telephoto, 500D Canon diopter for macro focusing, 2 seconds, f/32, tripod.

simplicity Patterns

One of the interesting ways to create images of simplicity is to find patterns in nature. Violating one of the rules of composition, where a point of focus is required, a pattern does not have a central point of interest: It is just a simple graphic statement.

Telephoto lenses are the best tools to locate patterns in nature. Long lenses allow you to eliminate extraneous elements and fill the frame with tiny portions of the whole so you can recognize artistic designs in rock faces, leaves, ripples in a stream, sand dunes, thunderheads, bark, feathers, flocks of birds, and many other subjects.

Wide angle lenses can also be used to photograph patterns, but the area that comprises the image is usually larger. If a particularly unique pattern of clouds covers the entire sky, a wide angle is ideal to record the event. The same is true for the ceiling of a cave or the pattern found in the crowns of aspen trees as you look toward the sky. Wide angles can also be used very close to subjects such as rock patterns on a cliff face or a mass of wildflowers.

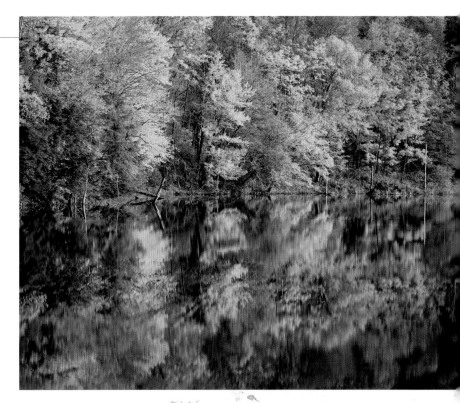

Simplicity has many guises. Unlike other pictures in this chapter where negative space, a single subject, and out-of-focus backgrounds define a simple graphic concept, this shot of autumn foliage in Vermont is simple in another way. It is, in essence, a pattern without a single subject on which the eye can focus. Although the whole of the image is comprised of myriad branches, leaves, tree trunks, abstractions of color, and shadows, it is not busy. When seen from a distance, the forest becomes a single subject, a simple mass of color.
🐾 *Mamiya RZ 67 II, 250mm telephoto, 1/8, f/22, Fujichrome Velvia, tripod.*

Similar in concept to the autumn foliage, this hillside in Southern California, which is covered primarily with poppies and lupine, is a pattern of color with no central point of focus. There is virtually no graphic design at all. It is simply a beautiful and subtle blend of color.
🐾 *Mamiya RZ 67 II, 350mm APO telephoto, 1/125, f/5.6, Fujichrome Velvia, tripod.*

peak
moments

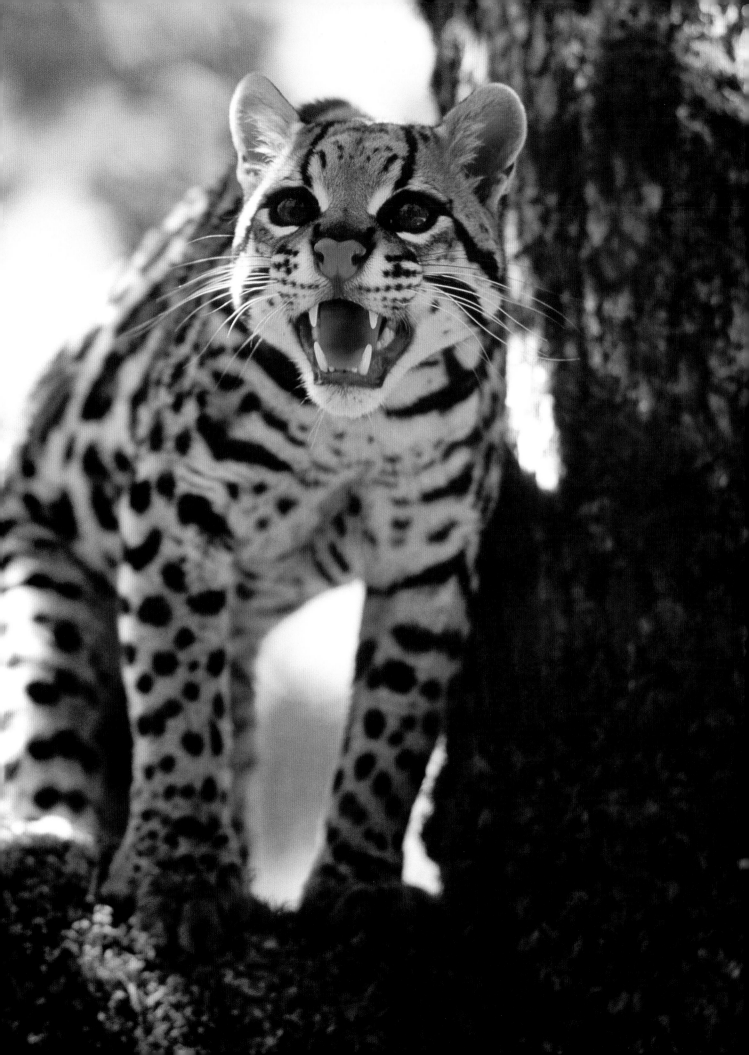

Introduction

One of the most exciting types of photographs to be taken in nature is a pinnacle event or peak moment. This often involves action: A lion roars, a brown bear catches a fish, a bird takes flight, or a butterfly emerges from its chrysalid. A peak moment can also involve a less obvious natural phenomenon, such as frost backlit by the morning sun or a hanging raindrop stretched to the limit on the tip of a leaf.

Peak moments usually happen very quickly. Some last only for a second or two, forcing you to shoot quickly and hope for the best. Others afford you more time to both appreciate the natural phenomenon and to photograph it with artistic forethought.

To capture these moments you must be constantly vigilant, particularly when shooting wildlife or when weather conditions are changing rapidly. Expect a peak moment at any time. I once lost a spectacular shot in Alaska when a 300-foot chunk of ice unexpectedly calved from a glacier. It was so awesome I was spellbound and neglected to capture the image. Focus on the picture taking — you can enjoy the experience later. This may sound like bad philosophical advice, but the number of dramatic images in your stock library will increase significantly.

You must also know your equipment like the back of your hand. Too many shots have been lost by photographers who were unfamiliar with a new camera body or were fumbling with loading a roll of film. Autofocus and autoexposure are invaluable tools in shooting quickly, and if available to you they should be used with moving subjects and changing light conditions. Don't think these innovative technologies take away your creativity: You're still in control.

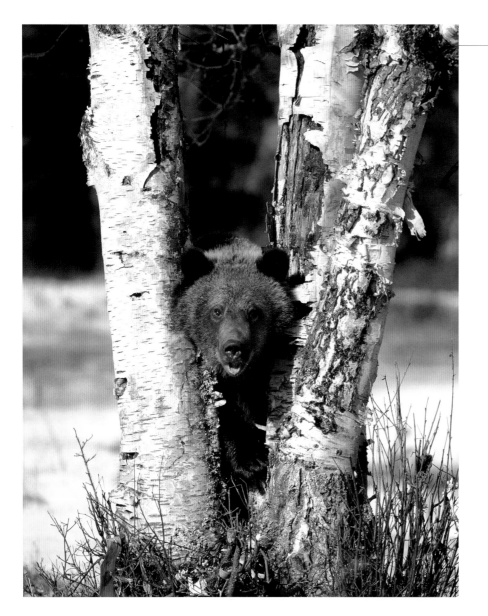

Humor is not easy to find in nature. It is a rare event when a situation becomes comical, and if you are fast enough and very lucky, you might capture it on film. The operative word, actually, is *fast*. This young grizzly was stuck momentarily in between the divergent trunks of a birch tree, and the expression on his face seemed to be one of embarrassment.

❧ *Mamiya RZ 67 II, 500mm APO telephoto, 1/250, f/6, Fujichrome Provia 100, tripod.*

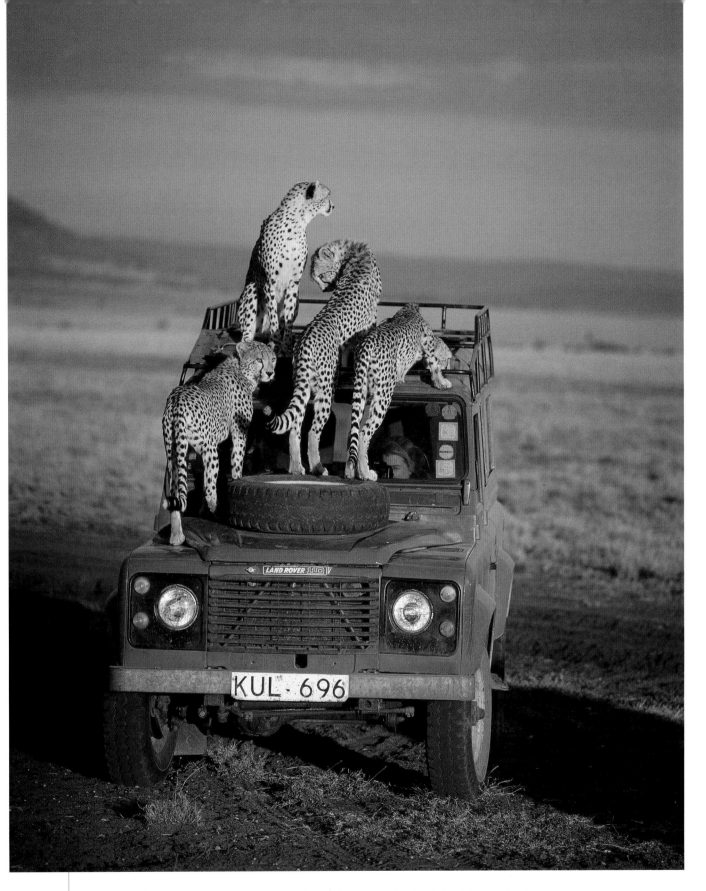

Certainly one of the most unique peak moments I've captured is this family of cheetahs on a Land Rover in Kenya. The mother had been injured, and the park rangers captured her so she could undergo treatment by a veterinarian. The female learned that people were OK, and she passed that knowledge to her cubs. Now this family uses vehicles instead of termite mounds to spot game on the flat plains of the Maasai Mara Game Park.

🐾 *Mamiya RZ 67 II, 350mm APO telephoto, 1/125, f/5.6, Fujichrome Provia 100, camera rested on a beanbag in a Land Rover.*

Know Your Equipment

It may seem obvious, but if you don't know your equipment well, you won't be able to shoot fast. If you can't shoot fast, you won't be successful in capturing peak moments that occur in the life of animals. Why? Because these special moments usually last only a second or two.

Learn everything you can about your camera until you know every button and LED readout. Practice loading film until it is second nature and takes only a few seconds. Be able to change lenses quickly. Understand the difference between aperture and shutter priority. Make sure you can recognize under what circumstances autofocus consistently fails (it always fails with subjects that have little or no contrast, like a blue sky or an Arctic fox on snow). Choose your exposure mode beforehand so you don't waste time when the action starts. Always have the camera manual available so you can review this information the night before if necessary.

It is also very important to own a tripod that is fast and easy to use. I see many amateur photographers struggle with their tripods. This will slow you down, cause endless frustration, and diminish your joy of shooting. My recommendation is to use a ball head on a light but sturdy support. I like the carbon fiber Gitzo with a Swiss Arca or a Foba ball head. Your choice must depend, however, on your own comfort level with the product.

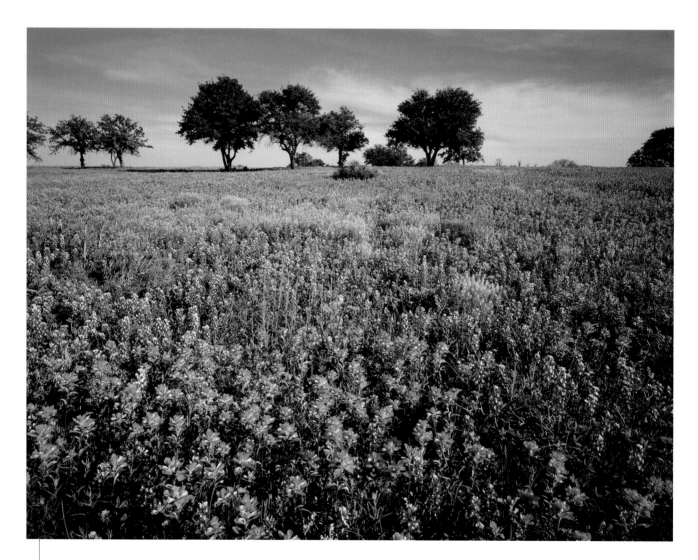

Peak moments in nature can occur in situations other than those involving animals. All over the world, spring flowers dazzle us with their color. In these circumstances, you have much more time to contemplate composition, choose the best time of day for optimal lighting, take advantage of depth of field, and select the appropriate lens. The flowers may only bloom for a few days, but this affords you the luxury of deliberation. When photographing animals, sometimes you only have a fraction of a second to get the shot.

❧ *Mamiya RZ 67 II, 50mm wide angle lens, 1/2, f/22—f/32, Fujichrome Velvia, tripod.*

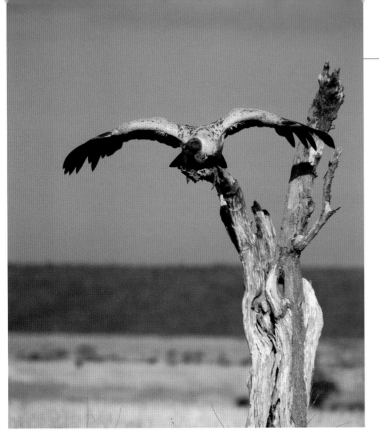

This white-backed vulture in Kenya was enjoying the morning sunlight, and after I took several pictures of him sitting motionless I wanted something more dramatic. I asked my driver to open and close his door, and as soon as the sound of the closing door was heard, the startled bird took flight. I had prefocused, composed the frame anticipating the outstretched wings, and preset my camera for the correct exposure.

🐾 *Mamiya RZ 67, 500mm APO telephoto, 1/125, f/6, Fujichrome Provia 100, camera rested on a beanbag in a Land Rover.*

Baby harp seals are adorable, but they usually lack any kind of apparent emotion. Once in a while, however, they will do something unique, and it is these moments that make it all worthwhile. I watched this little guy through the viewfinder for a long time before he rolled on his back and seemingly laughed at a private joke. In extreme cold, I tape a chemical heat packet on the side or bottom of the camera body to keep the shutter working properly and to prevent the film from becoming too brittle.

🐾 *Mamiya RZ 67, 250mm telephoto, 1/250, f/5.6–f/8, Fujichrome 50D, tripod.*

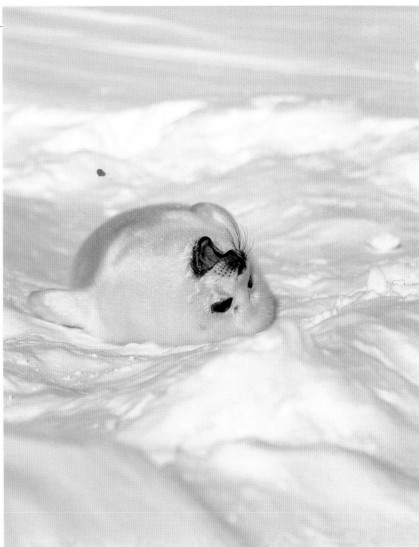

Photo
Research

One of the most important aspects of photographing great events in nature is knowing how to find them. A peak moment in the life of an individual animal usually can't be predicted, but locating the animal is certainly a prerequisite to getting the shot.

Peak moments regarding wildflowers, autumn foliage, spring greens, low tides, snowfall, and dynamic weather patterns also require research. Your photography will dramatically improve if you are shooting impressive phenomena in nature.

There are many sources of information available to us all. Photo magazines that focus on nature are excellent, and you should subscribe to several and keep a file of places you want to shoot. Calendars are also an excellent resource, providing the caption information reveals the location of each shot. I have many years of calendars from the Sierra Club, Audubon, and other companies that I refer to often. Books on nature and nature photography are also good (I always provide the location of pictures specifically to help others find great pictures).

In addition, natural history museums are a resource to learn about and find peak moments in nature. Scientists there can point you in many fascinating directions. Through museums, you can find out about natural history clubs that meet regularly. Years ago I joined a herpetology club and a lepidoptera club to learn more about locating unusual reptiles and butterflies.

I now use the Internet a great deal to find exciting things to shoot in the natural world. People love sharing information on the Net, and once you find chat rooms or bulletin boards on a specific topic, you can post questions that someone, somewhere, will answer. Recently I wanted to locate a butterfly farm in Bali, and when I posted the question on a butterfly bulletin board, within twelve hours a man in Taiwan E-mailed me the address of the farm.

Some of the most dramatic moments in nature occur during a peak moment of animal behavior. This picture of a hippopotamus in Tanzania is actually the result of two peak moments. The aggressive behavior of the gaping mouth is the obvious one. But the second peak moment is the lighting. This shot was taken about five minutes before the sun set. The beautiful golden light of a low sun is coveted in many natural situations; in combination with dramatic animal behavior it is extraordinary.

🦎 *Mamiya RZ 67 II, 500mm APO telephoto, 1/60, f/6, Fujichrome Provia 100, camera rested on a beanbag in a Land Rover.*

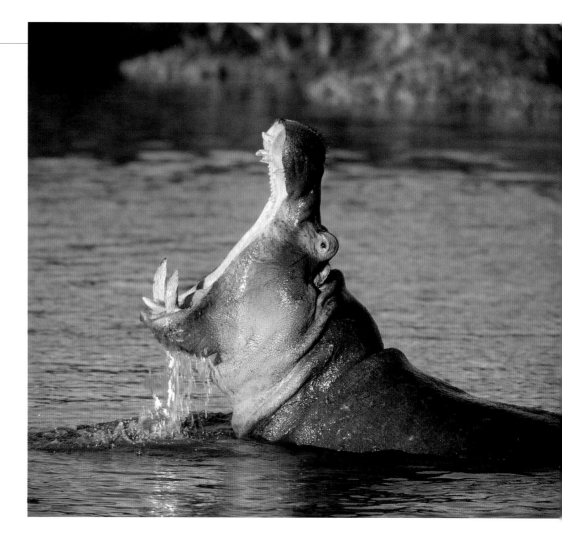

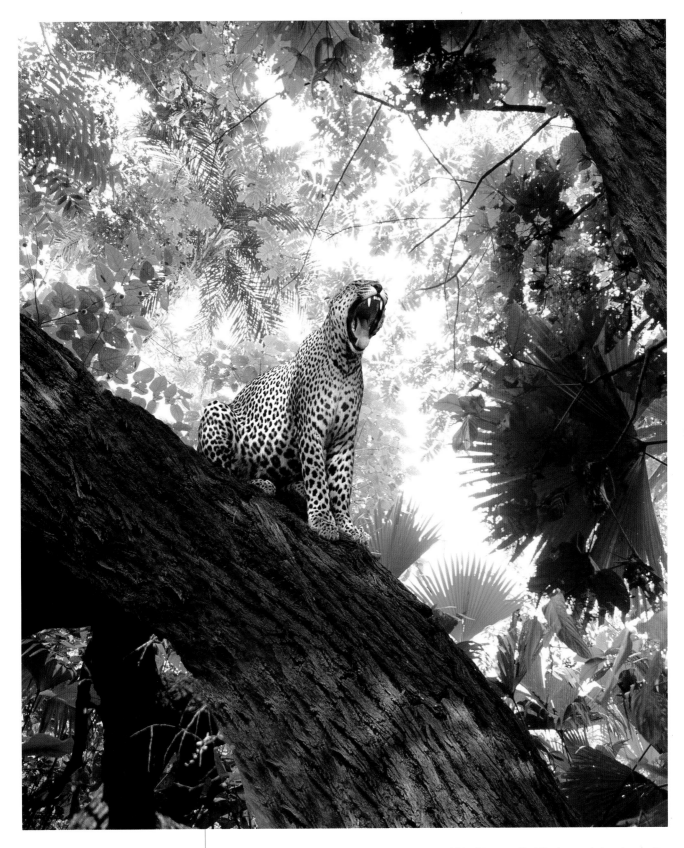

I waited a long time to get this picture. My driver and I had first spotted the leopard sleeping on the tree trunk in the early morning when the low-angled sun illuminated him perfectly. However, he was completely listless and had no interest in posing for photographers. For four hours he did nothing but raise his head once in a while. Then suddenly he sat up, yawned, and walked down the tree to the ground.

❧ *Mamiya RZ 67, 500mm APO telephoto, 1/125, f/6, Fujichrome Provia 100, camera rested on a beanbag in a Land Rover.*

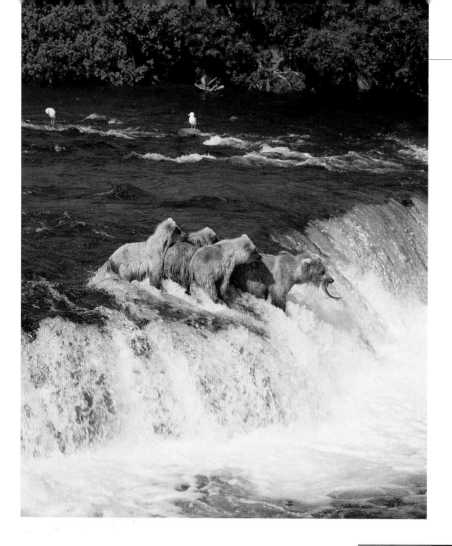

It took me four days to get this shot. This female brown bear and her three cubs were photographed at the Brooks River in Katmai, an island in southern Alaska. This is one of the most remarkable peak moments I've ever photographed, because there was only one time in four days when the mother and cubs looked in the same direction in good lighting. And at that instant a salmon jumped the falls and the female caught it; I made the shot a millisecond later.

🐾 *Mamiya RZ 67, 250mm telephoto lens, 1/250, f/8, Fujichrome Provia, tripod.*

There are occasions when a bear will "false charge" to scare off an enemy. In other words, the animal begins to charge and then abruptly stops. This avoids the actual confrontation because, in most instances, the technique of striking terror in the heart of a rival usually works. I can tell you that the word "terror" doesn't even come close to describing the feeling of a bear running right toward you with his small, beady eyes locked onto yours.

🐾 *Mamiya RZ 67, 500mm telephoto, 1/250, f/8, Kodak Ektachrome 400, tripod.*

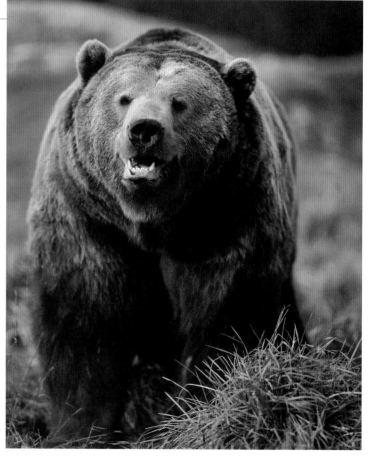

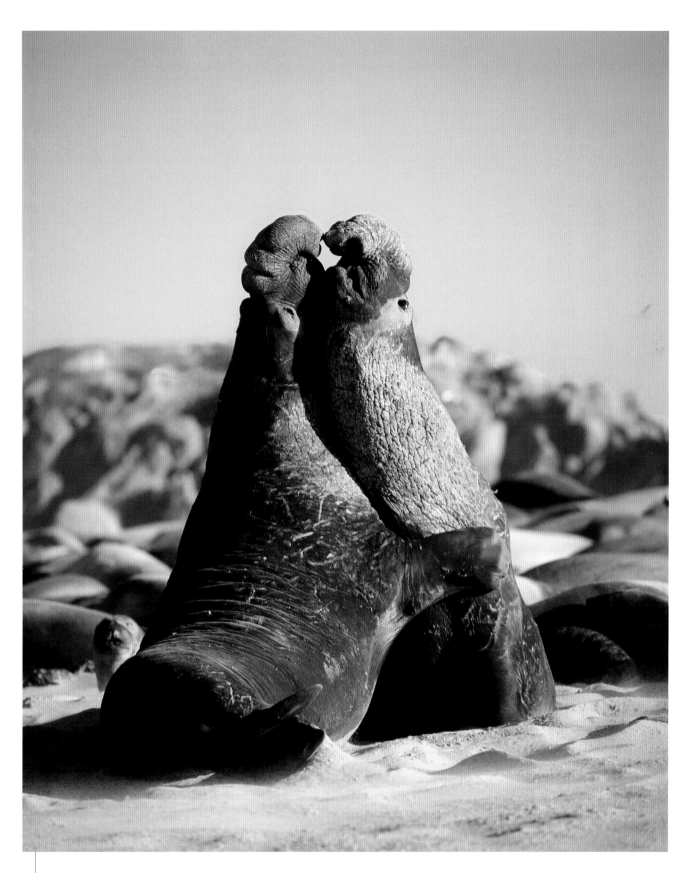

San Miguel Island is the westernmost point of land in the Channel Islands National Park near Ventura, California. Every year, thousands of northern elephant seals congregate to have their pups and mate. The beach they use is often so windy that blowing sand and salt spray provide a torturous environment for camera gear. The best way to protect gear from blowing sand is to put a clear, plastic shower cap over the camera and secure it with a rubber band.

❧ *Mamiya RZ67, 500mm telephoto, 1/125, f/8, Kodak Ektachrome 64, tripod.*

41

Shooting peak action in wildlife sometimes requires fast film. I resist using film faster than 100 ISO because I love the brilliant color and ultrafine grain of slow film. The three transparency films I would recommend for rich color and remarkable grain structure are Fujichrome Velvia, Fujichrome Provia III (This film was released after this book was completed. Fujichrome Provia 100 is no longer available.), and Kodak E100 VS.

In situations where the light level is low and a fast shutter speed is required to freeze movement in a subject, I will push these films one and sometimes two f/stops (pushing 100 ISO film one stop means you rate the film at 200 ISO; a two-stop push is 400 ISO). In doing this, the film is underexposed one or two stops (the whole roll must be pushed, not just a portion of it). The photo lab compensates for the underexposure by leaving the film in the developer longer.

A one-stop push is very satisfactory, with only a slight increase in grain. The color remains saturated. A two-f/stop push is acceptable if it's the only way to get the picture, but I don't like it. There is a loss in contrast and color saturation and an increase in grain. Modern films have minimized these disadvantages compared to films twenty years ago, but there is still a small but perceptible degradation of image quality.

The best way to avoid the inevitability of pushing film is to invest in fast lenses with large apertures for light gathering. A one-stop difference in aperture — say from f/5.6 to f/4, or f/4 to f/2.8 — is significant in low-light situations.

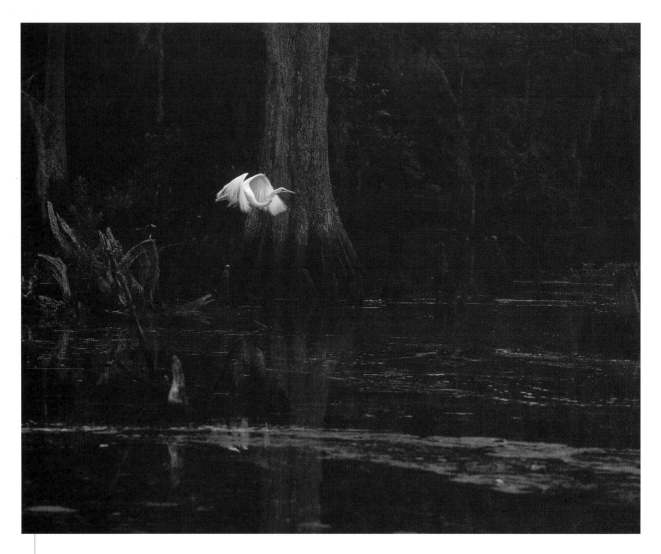

To capture peak action in extreme low-light conditions requires the use of fast film. Sometimes even fast film doesn't enable you to use a shutter speed fast enough to freeze movement. In those instances, you must push the film to a higher ISO. This egret was photographed in the Atchafalaya Swamp in Louisiana in murky light.

🦢 *Mamiya RZ 67, 500mm APO lens, 1/60, f/6, Ektachrome 400 pushed two f/stops to 1600 ISO, tripod.*

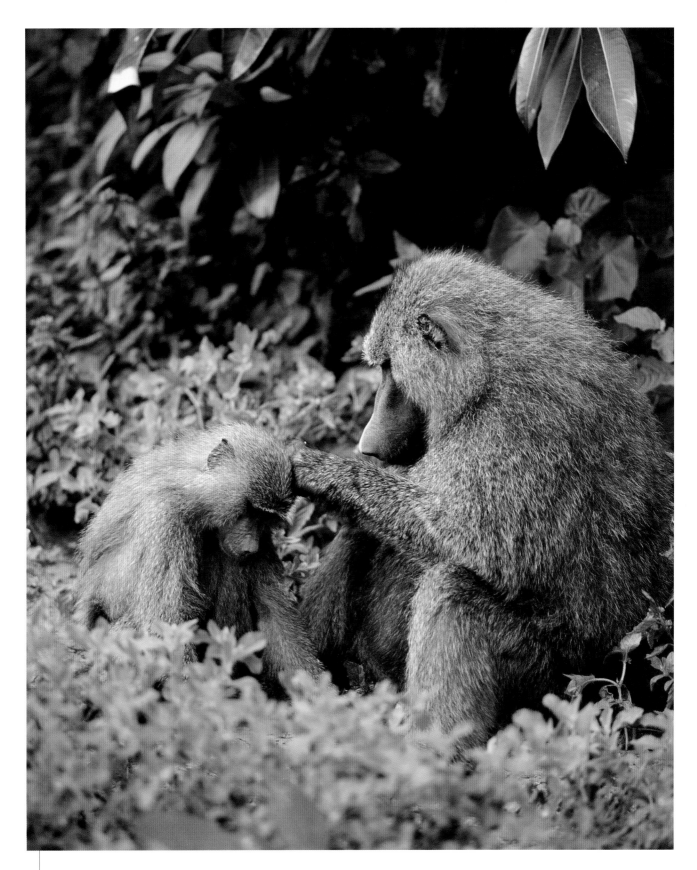

Relationships between animals, particularly between a mother and her young, present special opportunities for photographers looking for peak moments. These types of pictures are more salable, more endearing, and more rare than portraits of single animals. When you are lucky enough to find them, or patient enough to wait for them to happen, you will be rewarded with memorable images.

🦕 *Mamiya RZ 67 II, 350mm APO telephoto, 1/125, f/5.6, Fujichrome Provia 100 pushed one f/stop to 200, camera rested on a beanbag in a Land Rover.*

light

Introduction

The second most important component in making great images is lighting. Unlike studio photography, where you have total control over the light, photographers are at nature's whim when shooting outside. Only the time of day and the direction of the camera allow us to maintain some control over the lighting.

The two most effective types of lighting in nature are low-angled sunlight and diffused overcast light. Sunrise and sunsets offer the most dramatic lighting on almost every subject. The golden light and long shadows dramatize landscapes, wildlife, and macro subjects. Whenever possible, this kind of lighting should be used. Soft, diffused light works best for many, but not all, subjects. Wildlife and macro subjects work particularly well with shadowless light. Some subjects, such as dewy spider webs, autumn leaves on a forest floor, and glaciers, should only be photographed in diffused light. Other types of lighting are too contrasty for these subtle subjects.

Natural light that should be avoided, with few exceptions, is overhead sunlight. The harsh shadows and uncomplimentary lighting render even beautiful scenics worthless. Similarly, many animals with dark fur can't be effectively photographed in overhead light because the contrast makes it impossible to produce an attractive exposure.

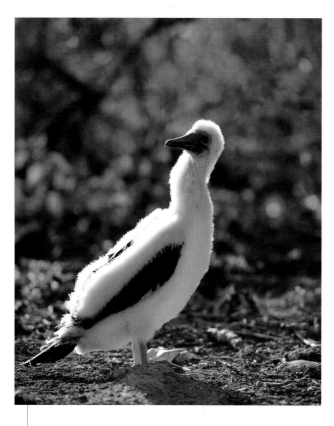

Backlighting delineates a subject from its background with a fringe of light. It is a powerful tool for photographers to dramatize both animals and plant life, particularly when the background is at least one f/stop darker than the highlights on the subject. This blue-footed booby downy photographed in the Galapagos Islands was captured about an hour before sunset. Twice each day, when the sun is low, look for striking backlighting, particularly on translucent subjects like feathers, leaves, and grasses.

Mamiya RZ 67, 350mm APO telephoto, 1/125, f/5.6, Fujichrome Provia 100, tripod.

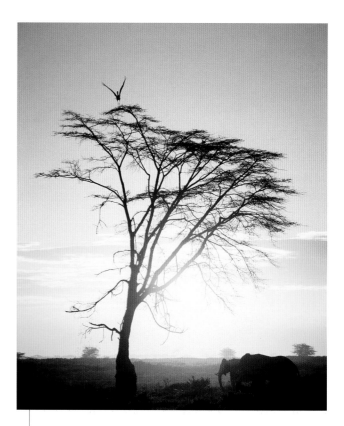

Some cloud formations disperse the light from a low sun so that the golden aura spreads across the sky and land. This tree in Amboseli Game Park in Kenya was placed against the sunset by moving my vehicle to an advantageous position. I waited for the elephants to walk into the frame, and then the Land Rover's door was opened and closed. The sound startled the stork and it took flight.

Mamiya RZ 67, 250mm telephoto, 1/250, f/8, Fujichrome Provia, camera rested on a beanbag in a Land Rover.

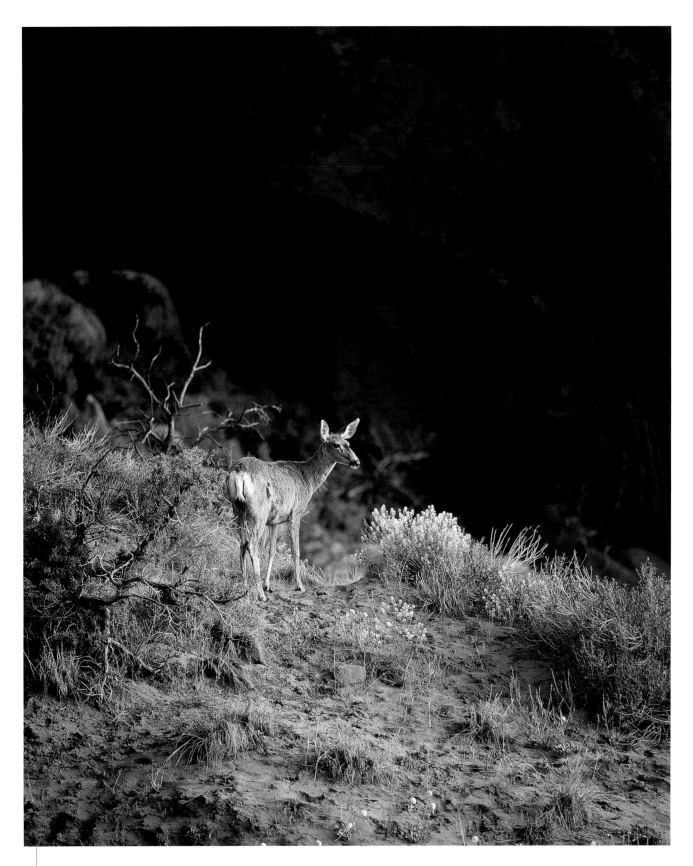

I was following a group of three mule deer in Arches National Park, Utah, when one of them stepped into the light just after sunrise. For only an instant, he turned toward the sun and held an elegant pose. I carry my camera already mounted on the tripod, so I was ready to shoot when he paused. The contrast between the sunlit area and the dark rock face forces all the attention on the deer.

Mamiya RZ 67, 350mm APO telephoto, 1/125, f/5.6, Fujichrome Provia 100, tripod.

47

Color

The color of natural light changes throughout the day. At noon on a clear day, the sunlight is considered white. When the sun is touching the horizon, either at sunrise or sunset, it washes the land with a golden color that is yellow with red. On overcast days, the color of light has a tinge of blue, and in deep shade or when the sky is dark and threatening rain, the light is a deeper blue.

These colors can be perceived by our eyes, but film records them in more pronounced tones. A landscape photograph or a portrait of an animal at sunset appears more yellow on the film than it did to our eyes. Similarly, in shade, we can perceive a bluish quality to the light (we use the term "cold" to describe the light), but film causes a significant shift so that all subjects that are white, like snow and ice, actually appear blue.

These inaccurate colors on film do not duplicate what we see, but they add artistry to nature photography. Yes, the inaccuracy can be corrected with filters, but I never do this. As you can discern from looking at the images in this chapter and throughout the book, the warm colors of a low sun and the blue tones of diffused light add a compelling element to an image.

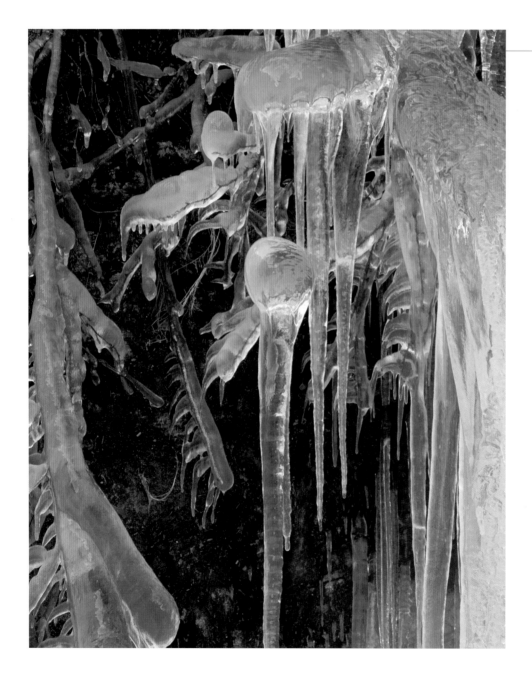

In deep shade, color film undergoes a color shift toward the blue end of the spectrum. This is true for any subject. This ice formation in the North Cascades National Park in Washington appeared white to my eyes, but it was on a cliff face under tall trees. The sun was shining and the sky was blue, but the deep shade caused the bluish cast in spite of the fact that Fujichrome Velvia has an inherent shift to red. Blue always implies the concept of "cold." Here it works. If you are shooting an animal, or a flower, you may not want a similar shift. A warming filter can then be used to help bring back the original tones.

Mamiya RZ 67 II, 350mm APO telephoto, 1 second, f/22, Fujichrome Velvia, tripod.

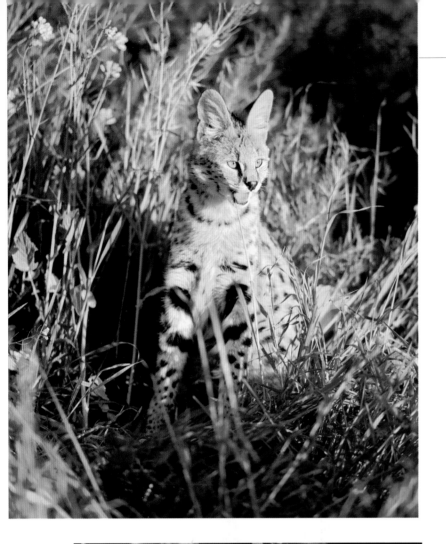

The golden light of sunrise or sunset is called "sweetlight" because it is the most beautiful light of all. In the few minutes twice each day when it is available for photography, the pressure is on to find a worthy subject. This serval cat photographed in the last few minutes before sundown was a lucky find.

🐾 *Mamiya RZ 67, 350mm APO telephoto, 1/250, f/5.6, Fujichrome Provia 100, camera rested on a beanbag in a Land Rover.*

Electronic flash is a harsh light and doesn't look natural, but sometimes it is necessary. This ocelot kitten was photographed in the Peruvian Amazon, and I was forced to use artificial light because the ambient light on the jungle floor was so dark. Even with 1000 ISO film I couldn't have taken a decent shot.

🐾 *Mamiya RZ 67, 250mm telephoto, 1/125, f/8, Metz 45 flash, Fujichrome Velvia, hand held.*

Polarizing Filter

In the decades before the 1990s, when photographic film was not as advanced as it is today, most photographers used a polarizing filter to alter both the color relationships and the light values in a slide. Neither Kodachrome nor the old Ektachrome films offered rich, saturated colors compared to modern films, and a polarizing filter was used to bring back some of the richness that our eyes were able to see.

Specifically, polarizers were used to enrich a blue sky. Puffy white clouds in contrast to the deep blue sky were quite dramatic. In addition, polarizing filters reduce or eliminate sunlight reflecting on bodies of water and plant surfaces, such as leaves and grass. This reduction of glare brought out the underlying green color, which was necessary because Kodachrome slides in particular gave desaturated greens.

I rarely use a polarizing filter today to achieve these effects. Fujichrome has been known for many years now to characteristically provide rich, beautiful colors, and Kodak film, E100 VS, does the same. If you use a polarizing filter with either of these emulsions, the saturation of the color will be unnatural and, in many instances, not pleasing.

I do carry a polarizing filter in my camera backpack, however, because I use it sometimes to reduce light. When I want to use a long shutter speed, such as four seconds, to blur moving water, the smallest lens aperture may not reduce the light enough to enable a long exposure. The polarizing filter acts as a neutral-density filter in this situation, cutting the ambient light by two-and-a-third f/stops. Thus, the longer exposure time becomes possible.

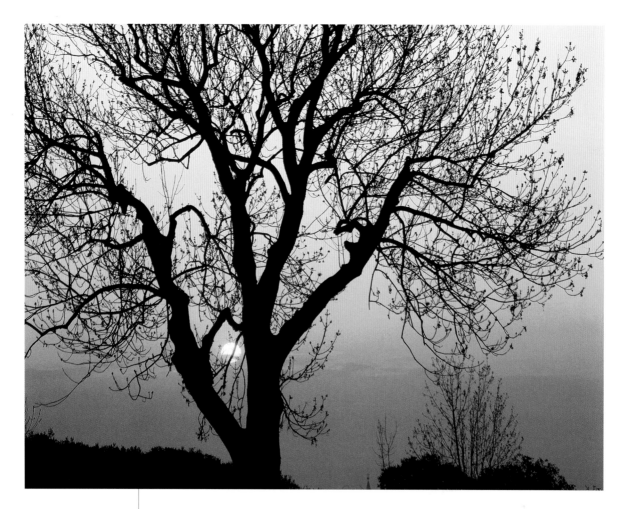

When the sun is low, you have many choices of lighting with regard to how the light strikes the subject. Front lighting, side lighting, backlighting, and transillumination are all possible. Silhouettes are easy to find as well, but it's important that the form of the subject be beautiful or striking in some way: Otherwise the picture won't work. This tree was photographed just after sunrise in Germany. Atmospheric haze in Europe is omnipresent during the summer months, and sometimes I use a polarizing filter to cut it. In this instance, however, I elected not to eliminate the ethereal haze.

❧ *Mamiya RZ 67, 250mm telephoto, 1 full second, f/32, Fujichrome Velvia, tripod.*

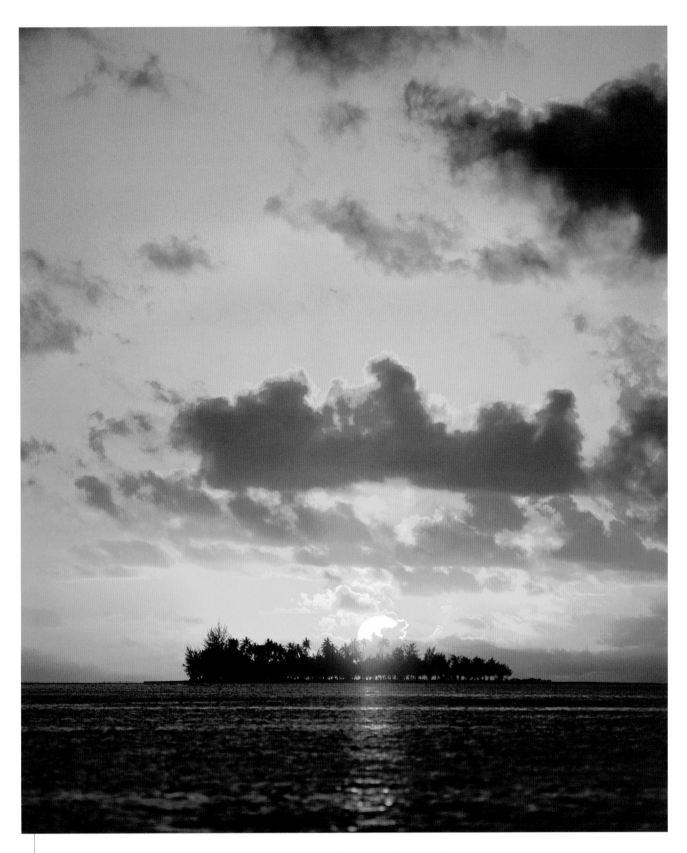

Shooting directly into the sun always adds drama to your work. This motu in the Bora Bora lagoon was photographed from a boat just as the sun was setting. The brilliant light from the sun will adversely affect the meter in your camera, so take the light reading from a neutral portion of the sky away from the sun. Then, use that exposure data to take the picture. Some photographers think that a polarizing filter is effective when shooting into the sun. This is not true. A polarizer does nothing in this situation except reduce the light hitting the film.

❧ *Mamiya RZ 67, 500mm APO telephoto, 1/250, f/6, Fujichrome Velvia, hand held.*

Weather Conditions

Weather constantly affects natural light. Some of the most compelling nature photographs have been taken when the sky is dramatic and the light on the land seems almost unearthly.

The most stunning lighting in nature, in my opinion, is when the eastern sky is black with storm clouds and the setting sun illuminates the landscape with golden light. The contrast between the yellow and the dark gray or black sky is exquisite. Never have I been more frustrated than when I see these conditions and there is nothing of interest in the foreground to photograph.

Another remarkable circumstance occurs when you can see great distances and low-hanging rain clouds miles away permit rays of sunlight to penetrate to the ground. This condition can be seen frequently every summer in Arizona during the monsoon season (July and August). You can often see this type of lighting in the afternoon, particularly from a mountain height looking down into a large valley.

Lightning is one of my favorite subjects to photograph in nature. The three hot spots in the United States where you can consistently see lightning are (1) Phoenix and Tucson in July and August, (2) the eastern Rocky Mountains south of Denver in May, and (3) Tampa Bay in Florida all summer. It's easiest to shoot lightning at night by leaving your shutter open at about f/5.6.

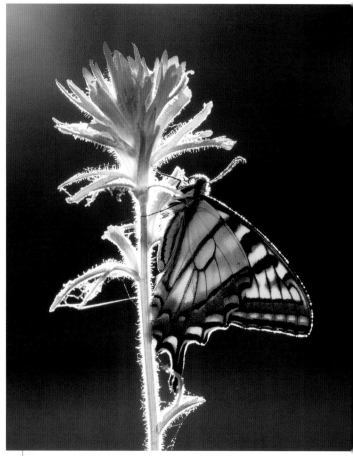

In muted light, when the sky is unchanging, you can take an ambient light reading with either your camera's TTL meter (pointing it at a Kodak gray card or some other middle-toned subject) or a handheld incident meter. Then all your shots under the same conditions will be correct. In this way, the white snow will not give you false readings.

❧ *Mamiya RZ 67 II, 350mm APO telephoto, 1/125, f/5.6, Fujichrome Provia 100, tripod.*

Early morning sunlight backlit this tiger swallowtail at the edge of a Michigan forest. The first few minutes of light at sunrise (or the last few at sunset) are always the most dramatic. This is the only picture in the book where I bracketed exposures. I took a spot light reading on a middle-toned portion of the wings and used that information for the shot (which turned out to be correct). Because this was such a difficult exposure situation I took additional frames, over- and underexposing in ½ f/stop increments — for insurance.

❧ *Mamiya RZ 67 II, 250mm telephoto, Canon 500D diopter, 1/8, f/16, Fujichrome Provia 100, tripod.*

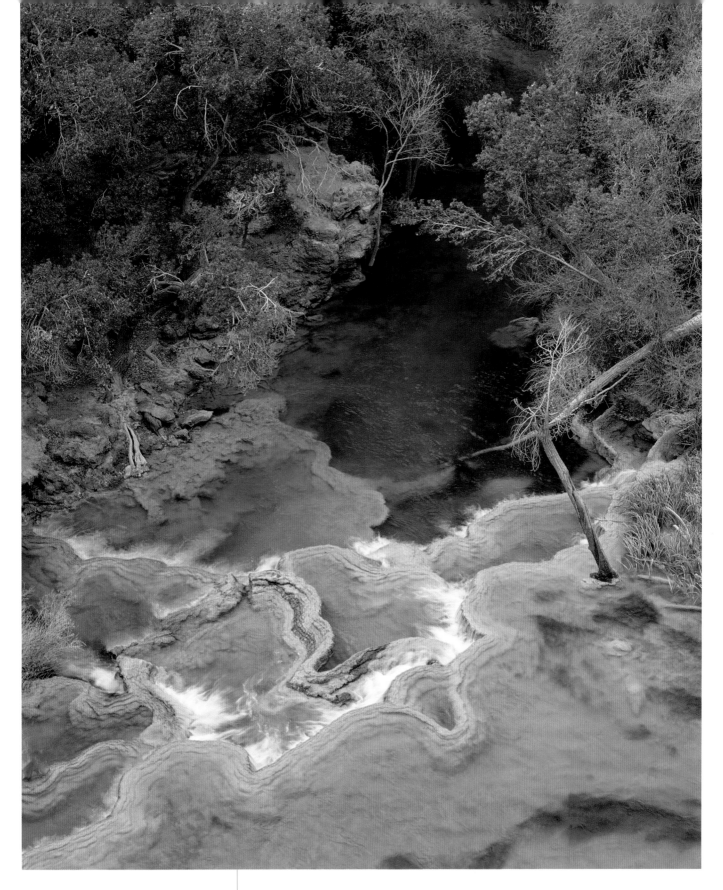

Many photographers think an overcast sky with muted light does not provide ideal circumstances to make nature images. For many subjects, this is not true. Shadowless light can bring out natural color with more saturation than with sunlight, and the soft quality of the light brings its own magic to a landscape. The bottom of Havasu Falls in Arizona is an exquisite sculpture of mineral deposits and turquoise water. This perspective was gained by shooting from the top of the falls straight downward.

❧ *Mamiya RZ 67, 180mm telephoto, 1/2, f/22, Fujichrome 50D, tripod.*

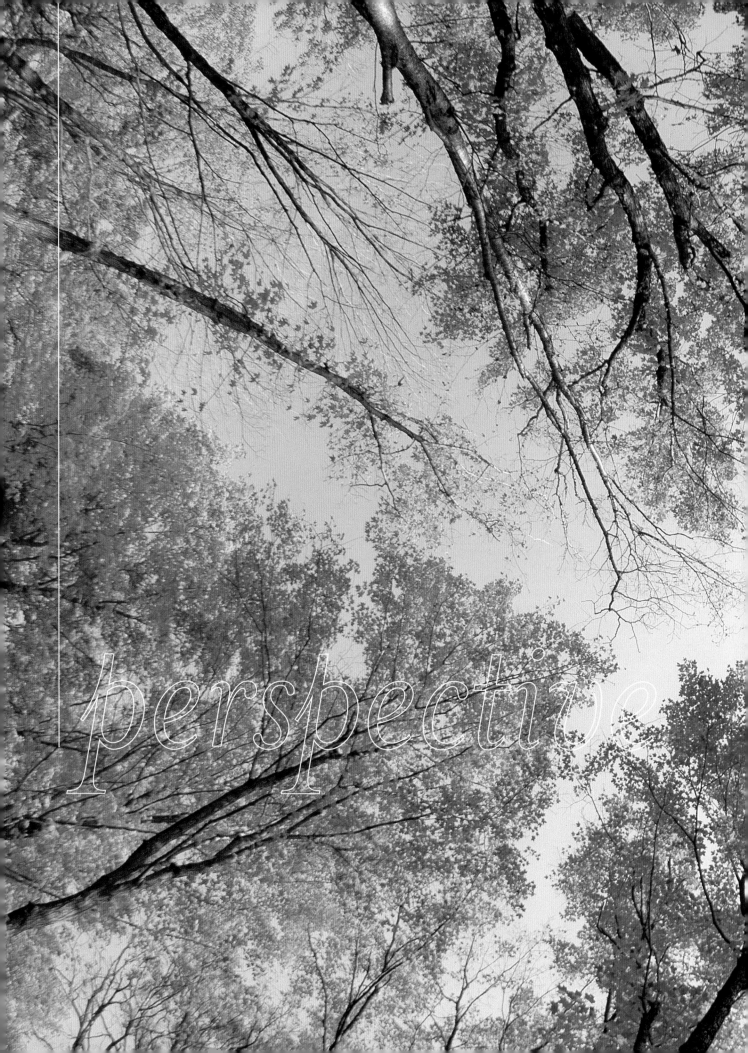

perspective

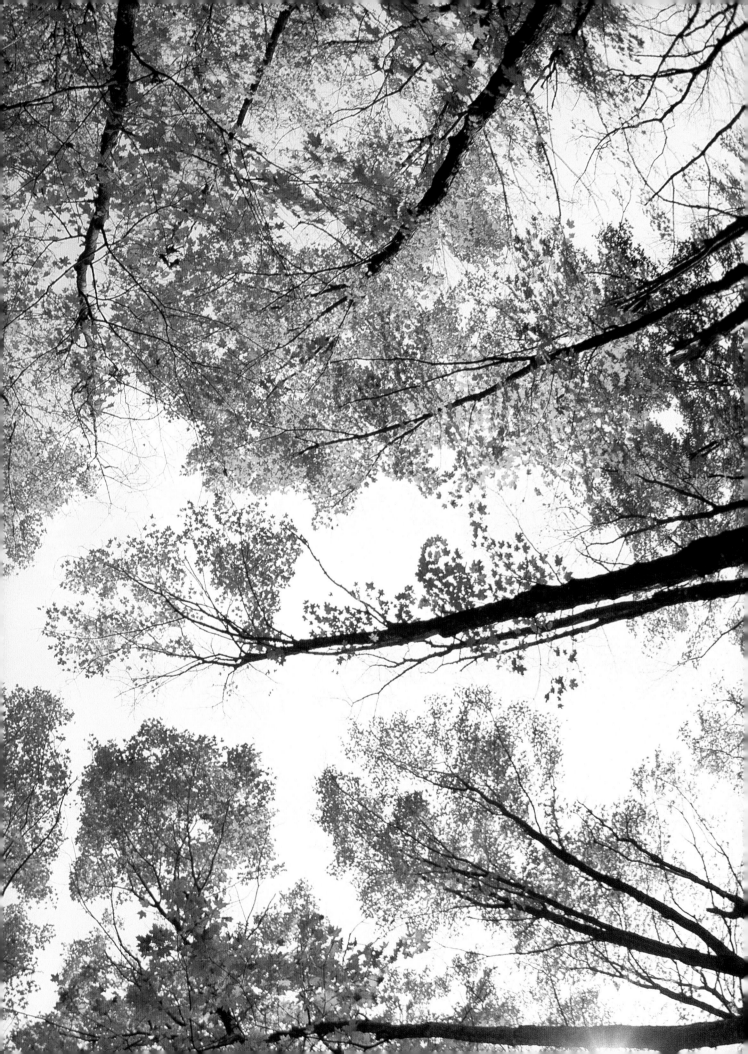

Introduction

As photographers we have no control over weather conditions or the available light at any one time, but we do have total control over the perspective of each shot we take. The choice of lens and the point of view are entirely of our making. The artistry of our photography can be enhanced, and dramatized, by judiciously choosing the perspective of each picture.

Wide angle lenses give a unique perspective to many subjects in nature, particularly landscapes. By placing the camera position close to an interesting subject, the foreground dominates the frame and the background appears much smaller by comparison. Close-up images using wide angles also offer a unique perspective. The macro subject seems to have more depth than if it were photographed with a normal or telephoto macro lens. Close-up portraits of wildlife with wide angle lenses are unusual principally because they are so rare: Very few animals allow such a close approach, but when you are lucky enough to be able to frame such a photograph, it is a true prize.

Long lenses can also provide unique perspectives. Animals camouflaged in tall grass, for example, are best photographed with a telephoto in which some of the foreground foliage is out of focus, suggesting we are peering into the private world of the subject. Telephotos also allow photographers to isolate a graphically pleasing composition in which everything that detracts from an artful image can be eliminated. The point of view we select will make or break the picture.

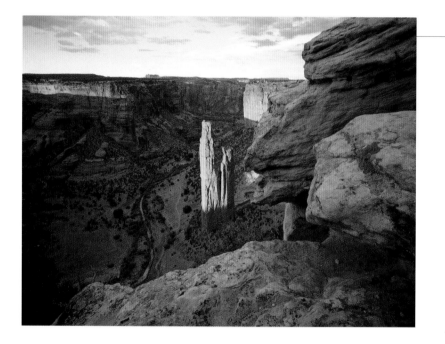

This photo exemplifies a classic landscape technique that offers a very dramatic perspective of nature. It involves three elements: a wide angle lens (the wider the angle, the more dramatic the effect), a small lens aperture, and a camera position that is physically close to the foreground. With a 24mm lens in the 35mm format or a 50mm lens in the 6cm x 7cm format, focus about eight feet into the frame for maximum depth of field. This shot of Spider Rock in Canyon de Chelly, Arizona, was taken about five minutes before sunset.

❧ *Mamiya 7, 43mm lens, 1/4, f/22, Fujichrome Velvia, tripod.*

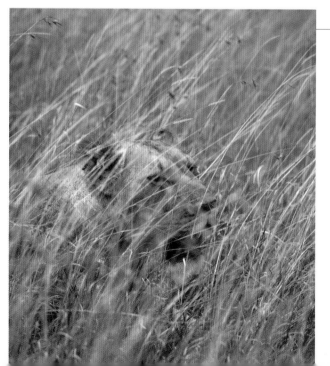

Many camera club competitions would criticize this image because the lion isn't clearly visible. The tall grass is a distraction, they would say. Sometimes distracting elements in front of a subject are indeed undesirable, but in this instance I would disagree. This perspective, where we can see how the cat is camouflaged in the tawny environment, implies a sense of real danger. Don't constrain yourself to the narrow rules of others.

❧ *Mamiya RZ 67, 350mm APO telephoto, 1/125, f/5.6, Fujichrome Provia 100, camera rested on a beanbag in a Land Rover.*

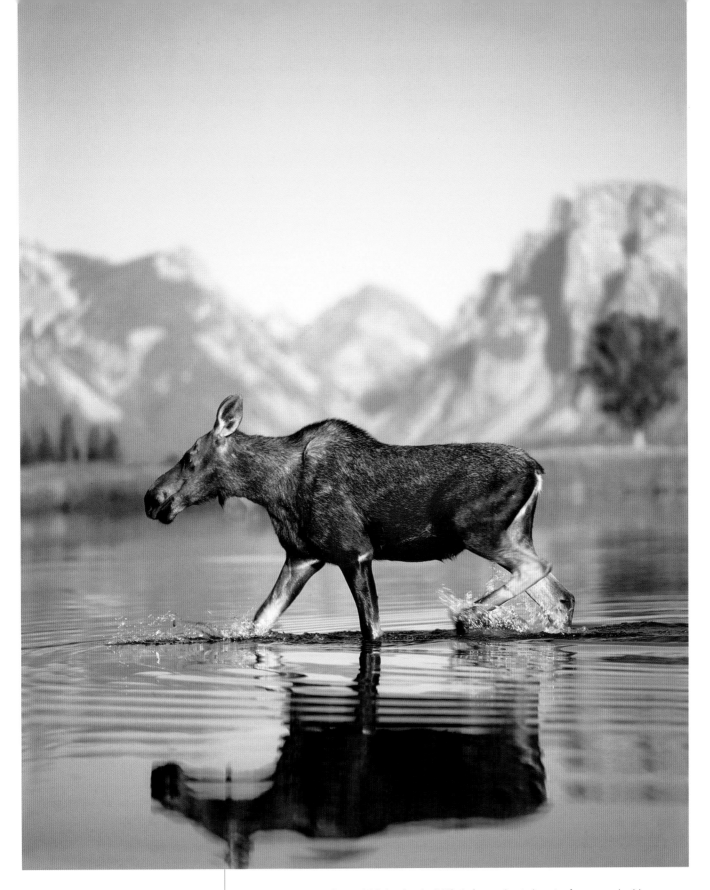

A unique perspective from which to shoot wildlife is from a boat. A water foreground adds a different kind of environment, particularly with animals not normally found in water. Herbivores such as moose often permit people to approach them much closer from the water than from land. Instinctively they expect danger from the trees or tall grass. Photographers can use this knowledge to get very close, sometimes within 15 or 20 feet, by quietly gliding toward them in a small boat.

Mamiya RZ 67, 250mm telephoto, 1/250, f/8–f/11, Fujichrome Provia 100, hand held.

Viewfinders

Shooting from a low perspective can be both painful and awkward with an eye-level viewfinder. All 35mm cameras are designed to be held up to your eye to compose each picture. Some cameras, however, also offer the option to replace the eye-level viewfinder with a waist-level viewfinder. This allows you to hold the camera at chest or stomach level; you look down into a viewfinder to take the shot.

This accessory is invaluable in many circumstances. When you do macro photography close to the ground, instead of lying on the ground and bending your neck in an unnatural angle to view the subject, a waist-level finder solves the problem. You can rest on one knee while focusing on and photographing the subject.

The same is true when shooting animals close to the ground from a low perspective: A waist-level finder allows you to shoot comfortably without breaking your neck. In addition, many animals are intimidated by direct eye contact, and they flee out of photographic range when you look at them. Looking down into a viewfinder means that a closer approach to nervous subjects may be possible.

Waist-level finders are used best when composing photographs with a horizontal orientation. If you try to shoot vertically, this type of finder becomes extremely awkward.

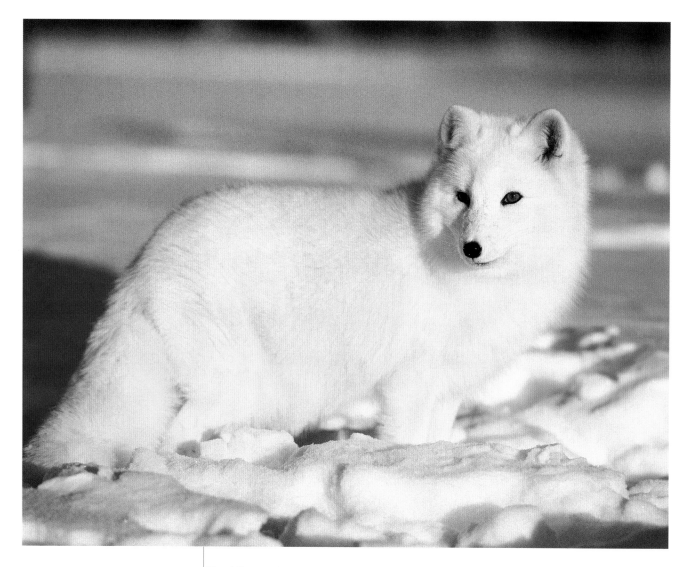

The difference between shooting small animals from a standing position and photographing them on their level is significant. I was on my stomach in the snow when I shot this Arctic fox in late afternoon lighting. The success of this picture is largely due to the low perspective.

Mamiya RZ 67 II, 350mm APO telephoto, 1/250, f/8, Fujichrome Provia 100, tripod.

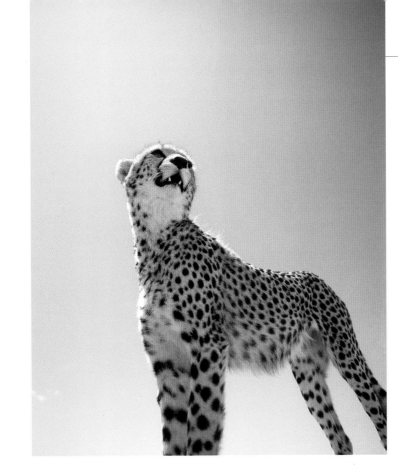

This is certainly one of the most unusual perspectives from which to shoot a cheetah. This is not a captive animal; it is one of the cheetahs I had photographed the day before on the Land Rover (see photo on page 35). On this day, the family of four was on my vehicle. When I took this shot, I was actually sitting in the middle seat of my Land Rover with the roof hatch open.

🐾 *Mamiya RZ67, 50mm wide angle, 1/125, f/8, Fujichrome Provia 100, hand held.*

Wide angle close-ups are a favorite technique of mine, because the perspective is a surprising one: It's not what a viewer expects. Close-ups are particularly unusual with wildlife because most animals are photographed from a distance with a long lens. Only in rare situations, such as in the Galapagos Islands, can wild animals be approached close enough to use a wide angle lens.

🐾 *Mamiya RZ67 II, 50mm wide angle, 1/250, f/8, Fujichrome Provia 100, hand held.*

59

Distortion

In my seminars and workshops I am often asked to recommend which wide angle lens and which telephoto lens a student should purchase. When I suggest an ultrawide angle lens, such as a 17mm, 20mm, or 24mm for the 35mm format, a common response is, "Doesn't that lens cause distortion?"

The answer, of course, is yes it does. No wide angle lens, in fact, captures what we see with our eyes. To a greater or lesser degree, wide angle lenses exaggerate perspective by elongating elements in the composition. This is especially true of the foreground. Telephoto lenses also do not reproduce reality as we see it. Telephotos compress perspective so that the elements in a scene seem squeezed together. In addition, they create out-of-focus backgrounds. Our eyes do not do this.

My point is that photography only approximates what we see. It does not, and can not, reproduce *exactly* what we see. A normal lens comes closest, but even it doesn't duplicate sight. No lens, for example, has peripheral vision. And our eyes see in three dimensions, while lenses can only capture two dimensions.

Instead of trying to reproduce reality, photographers can use the characteristics of photographic lenses — including distortion — to create something unique, dramatic, and artistic. In this sense, the distortion, so obvious in wide angle lenses, is only another tool to express your inner vision of the world.

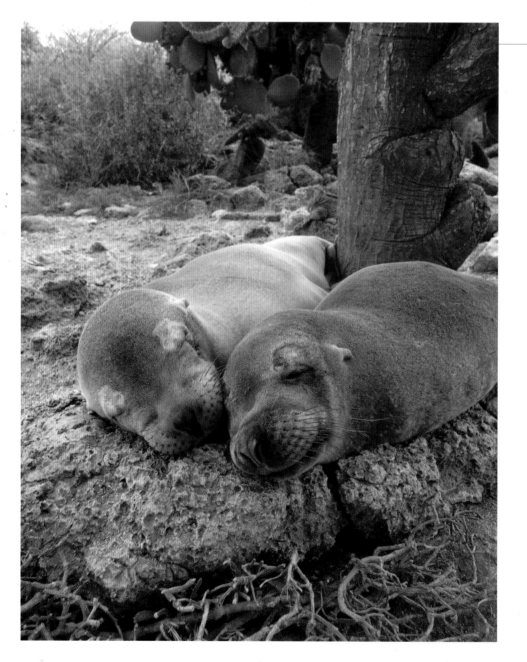

The same landscape technique I described in the photo on page 56 was used here, but its success was predicated on the fact that these sleeping sea lion pups in the Galapagos Islands weren't moving. The extreme wide angle perspective does in fact distort the animals, but distortion isn't always pejorative. In this instance, the exaggerated perspective adds an interesting artistic element to the shot. The camera position was about twelve inches from the two noses.

Mamiya RZ 67 II, 50mm wide angle, 1 second, f/32, Fujichrome Provia 100, tripod.

When wide angle lenses are used in photography and the film plane in the camera is oblique with respect to the plane of the subject, parallel lines are optically distorted so that they appear to converge. In reality, all of the trees in this shot appeared approximately parallel with each other. But from the perspective of a wide angle, they appear to be converging inward to a central point. This distortion occurred because I angled the camera upward to compose the image.

🍂 *Mamiya RZ 67, 50mm wide angle, 1/15, f/16–f/22, Fujichrome Velvia, tripod.*

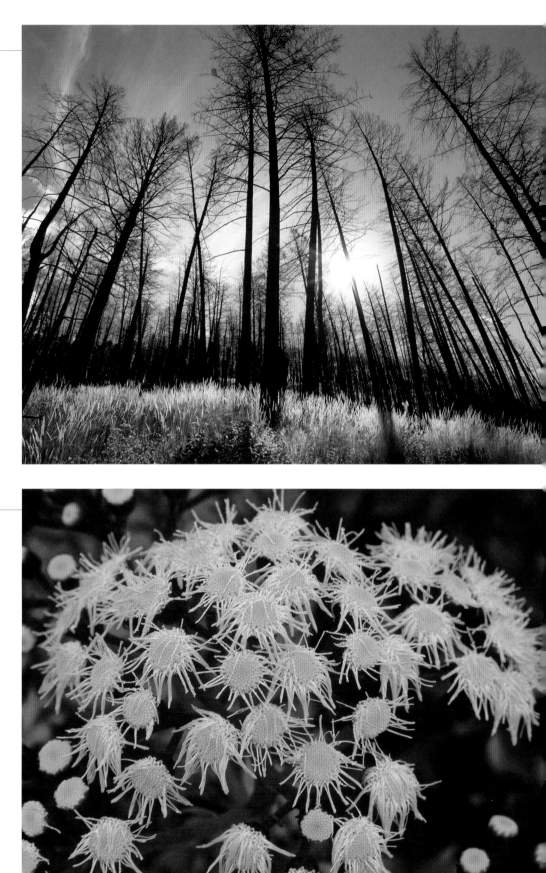

This photograph of flowers in Papua, New Guinea, is obviously a macro shot, but it was not taken with a macro lens. Instead, I used a 50mm wide angle lens (approximately comparable to a 24mm in the 35mm format). This is not a common usage for wide angle lenses, but sometimes they offer a very unique perspective when placed very close to the subject. I was only two or three inches away from the middle flowers.

🍂 *Mamiya RZ 67 II, 50mm wide angle, 1 second, f/32, Fujichrome Velvia, tripod.*

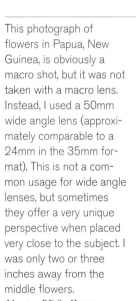

Aerial Perspectives

Shooting from an airplane is a fantastic way to capture striking graphic images impossible to see from the ground. Small planes (specifically high-winged planes, which are designed with the wings above the windows) and helicopters offer the best opportunities for composition. I usually fly at an altitude of 500 to 3,000 feet, and the two lenses I use the most are a medium telephoto and a wide angle.

All of my aerial pictures are taken with the lens aperture wide open. I do this for two reasons. First, depth of field is not a consideration. Everything is at optical infinity (unless a portion of the plane is included), which means that all portions of the frame will be in focus. Second, the larger aperture permits more light to strike the film, which in turn allows you to use a faster shutter speed. Due to the significant vibration of the plane, a fast shutter speed is required or your images will not be sharp. In addition, if you are forced to shoot through a window, imperfections in the plastic must be kept out of focus. A large aperture does this. If at all possible, however, have the door of a small aircraft removed so you can shoot without degrading the quality of your photos.

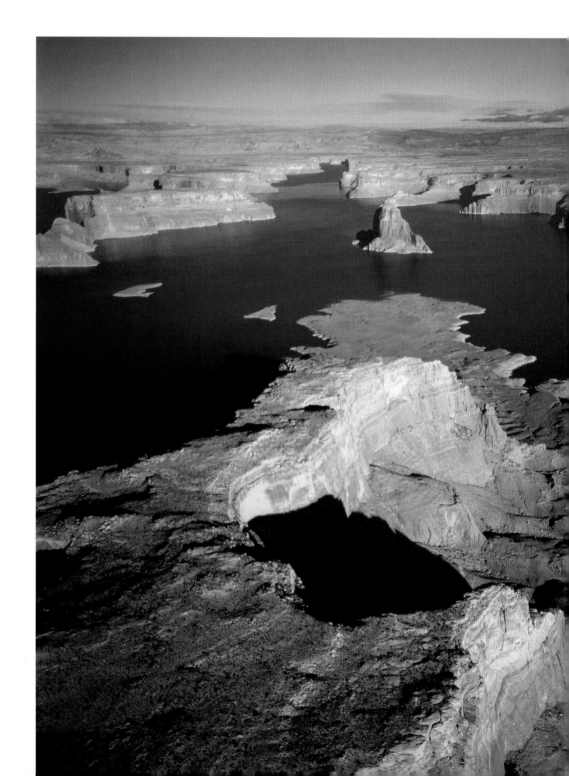

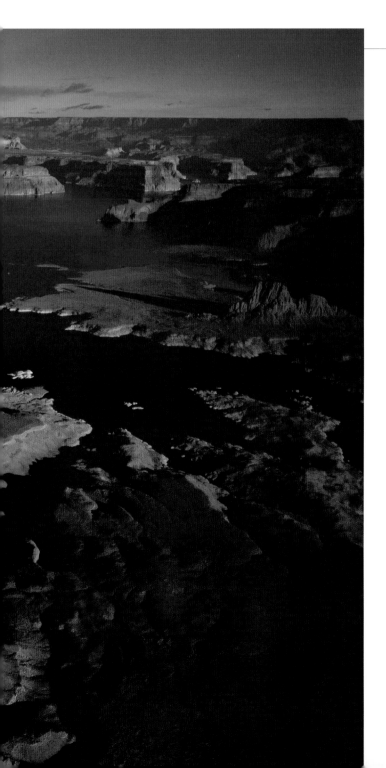

Taking photographs from an airplane is a totally different experience than shooting on the ground. The aerial perspective requires that you think graphically because, from the air, landforms appear to be primarily shapes and colors.

Mamiya RZ 67 II, 50mm wide angle, 1/400, f/4.5, Fujichrome Velvia, hand held.

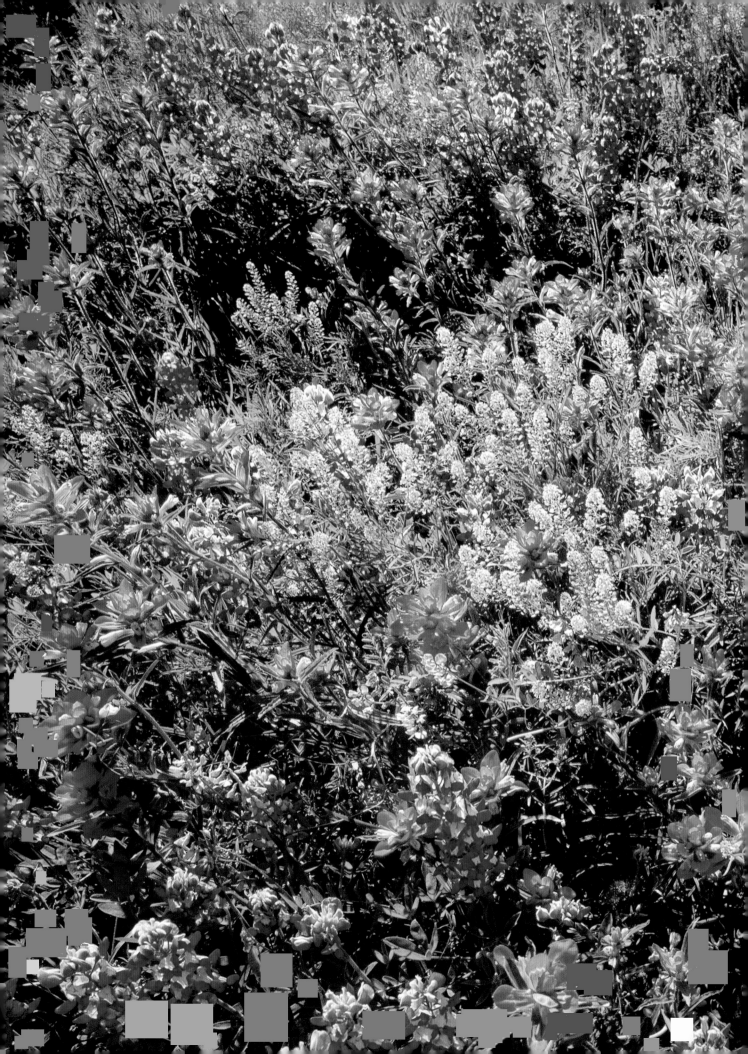

color

Introduction

One of the most exciting tools for capturing drama in nature in a photographer's arsenal is the use of color. Brilliant colors abound in the wild, and the combination of shocking colors compels our attention. At the same time, subtlety in color is dramatic in itself, and the soft, gentle color schemes that comprise many aspects of nature — from pastel clouds to the delicate hues in a wildflower — go into making brilliant images.

I am constantly on the lookout for beautiful colors and color combinations in nature. Certain events that are ablaze with color occur periodically in nature. Wildflowers bloom annually in many locations around the United States and the world, such as the California poppy in the hills near Gorman, California, and the Texas bluebonnets near Austin. Fall foliage in New England and other parts of America is another annual event that is simply stunning to photograph. The autumn migration of monarch butterflies to Mexico is an example of a remarkable color event in the animal kingdom.

Using color to your advantage does not only entail finding it: It is also important to compose the color elements in a creative manner. Juxtaposing two or more colors (for example, including several colorful wildflower species together in the same frame) or isolating a single colorful subject in an otherwise muted environment are techniques that will help you make powerful visual statements. And by combining the idea of the effective use of color with the other subjects discussed in this book, such as motion, perspective, and simplicity, you will be able to create some award-winning, or at least very salable, pictures.

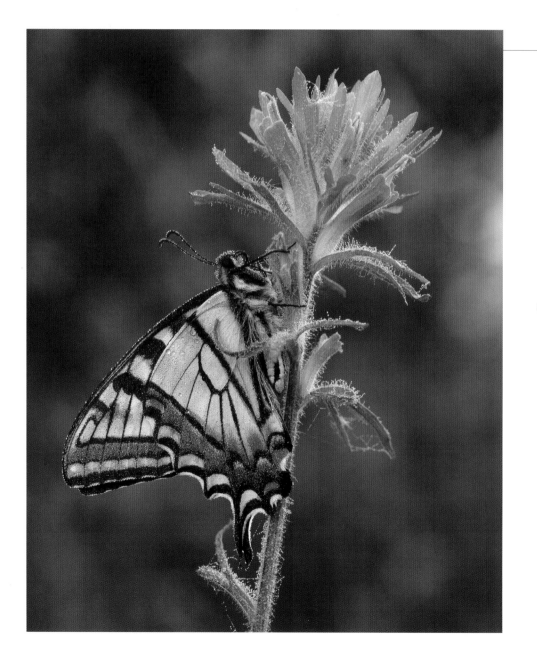

Compare the color of this picture with the swallowtail photo on page 52. It is the same subject taken only minutes earlier, before sunrise. In the diffused ambient light of dawn, the color of the swallowtail and its environment is completely different. Instead of being backlit with golden light, the yellow butterfly and bright red Indian paintbrush appear bluish and very cold.

Mamiya RZ 67 II, 250mm telephoto, Canon 500D diopter, 1/8, f/8, tripod.

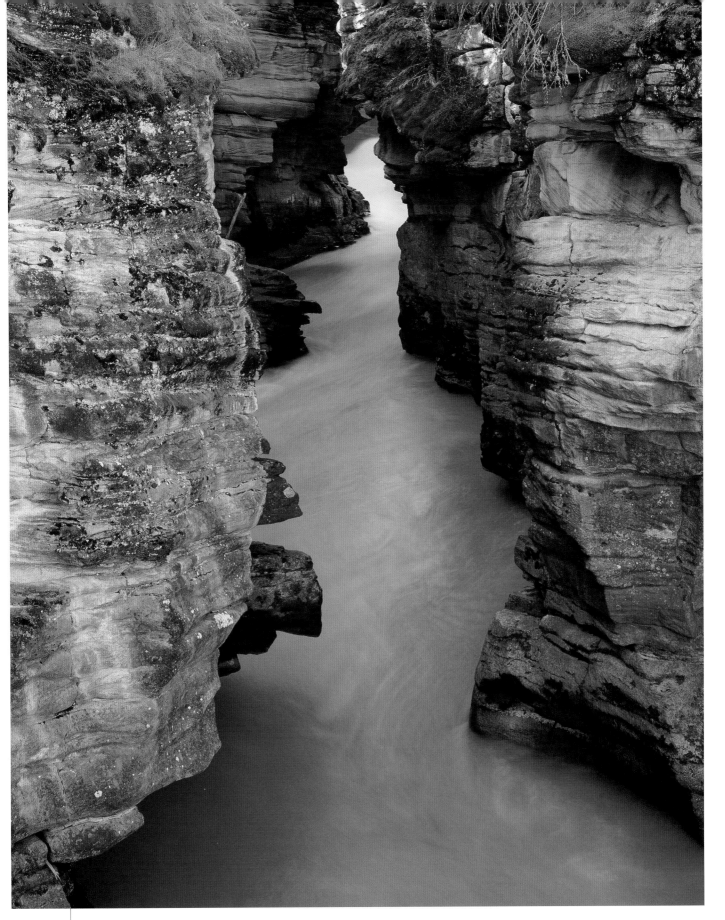

Unexpected colors can have a surprising impact on a photograph. The glacial melt water from an ice field in the Canadian Rockies is typically turquoise blue, and the contrast with the gray rocks is quite dramatic. I took this picture from a bridge just above Athabasca Falls in Alberta, Canada.

Mamiya RZ 67, 50mm wide angle, 1/2, f/22–f/32, Fujichrome 50D, tripod.

Combinations

Many color combinations in nature photography are dramatic. Contrasting and visually arresting colors, such as the flowers on pages 24–25 and the moth on page 27, are effective in riveting our attention on an image. At the same time, great subtlety, such as the muted landscape on page 20, does the same thing in a very different way and evokes a different emotional response.

Another technique I like is combining different shades of the same color in a single composition. Green on green, for example, as seen in the photo of a hillside forest on page 110, exemplifies this idea. The myriad shades of green trees blend together beautifully. On page 48, the photo of an ice formation uses many shades of blue to comprise the entire composition, which relies on form and color for its impact. The baby harp seal on page 37 illustrates the use of white on white: The entire frame is devoid of color except for the baby harp seal's tongue. The lion and tall grass on page 56 show numerous shades of tawny yellow filling the frame.

Seeking out specific combinations of color when you are in the field is difficult bcause you usually cannot predict what you'll find. Being aware of the possibilities, however, will increase your ability to use color to make powerful statements with your photography.

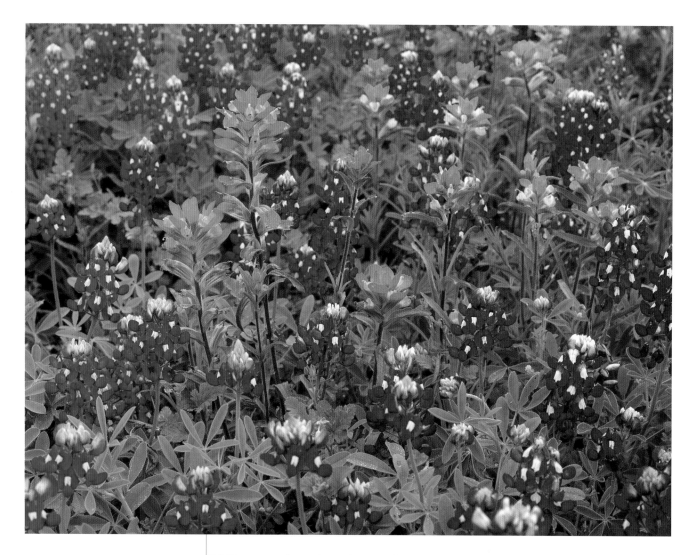

Wildflowers are the easiest subjects to find to make bold statements of color. Soft, diffused light always brings out their color in the most saturated tones. These bluebonnets and Indian paintbrush in Texas were photographed under a thick cloud cover. Much patience was required to wait for a lull in the wind.

🐾 *Mamiya RZ 67 II, 110mm normal lens, 1/4, f/22, Fujichrome Velvia, tripod.*

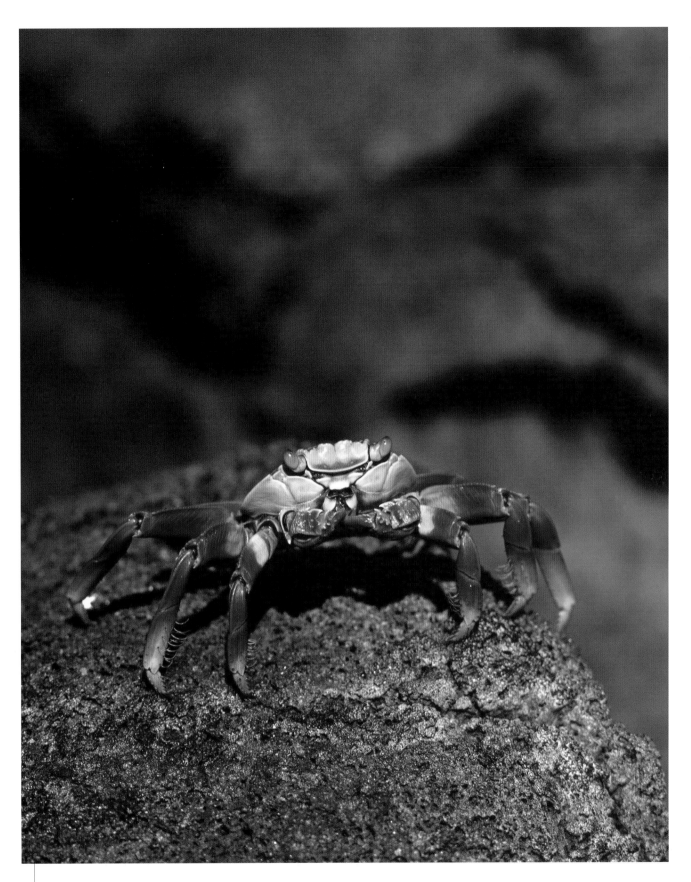

A brightly colored subject against a dark background is usually a formula for photographic drama. Sally lightfoot crabs in the Galapagos Islands spend their lives on black lava, which makes it easy to produce a classic image in which color is the main focal point. Note the low angle I used here: I spread the tripod legs parallel to the ground to take this intimate portrait.

Mamiya RZ 67 II, 350mm APO telephoto, #1 extension tube, 1/250, f/5.6–f/8, Fujichrome Provia 100, tripod.

Film Choice

Each film has its own color characteristics. For most of my nature photography, I prefer Fujichrome Velvia because it offers ultrasaturated colors and is exceptionally sharp. Some photographers feel Velvia is unnaturally saturated, and this is indeed true: The depth of color offered by this film does not reproduce what our eyes see.

Velvia has two disadvantages. It does have a red bias, which means that it can shift toward the red end of the spectrum. When shooting red subjects this can be a plus, because the red becomes incredibly saturated. However, when shooting pastel or very light subjects, like clouds or the delicate hues of an orchid, Velvia's red shift can be undesirable. In addition, this film is quite contrasty. If your lighting has much contrast, Velvia can cause a loss of detail in the highlights and shadows.

Fujichrome Provia III and Kodak's Ektachrome E100 VS are both excellent choices for several reasons. Their color saturation is superb and realistic without going overboard. If you don't like Velvia because it's *too* saturated, you will probably like these two films very much. In addition, you have the additional speed for shooting wildlife. You will notice that almost all of the wildlife photos in this book were taken with a 100 ISO film. Both of these films can be pushed one f/stop without an appreciable loss in color saturation.

Faster films such as Agfachrome 200, Fujichrome Provia 400, and Ektachrome 400 are convenient when light levels are low, but as the film speed increases, the saturation of color decreases. This is unavoidable. The new Fujichrome MS 100/1000 minimizes the problems inherent in pushing film more than one stop, but it just can't compare to a slow, fine-grained film for rich color, a tight grain structure, and good contrast. Of course, if you have to make the decision between missing the shot with a slow film or getting it with a fast film, you don't have much of a choice.

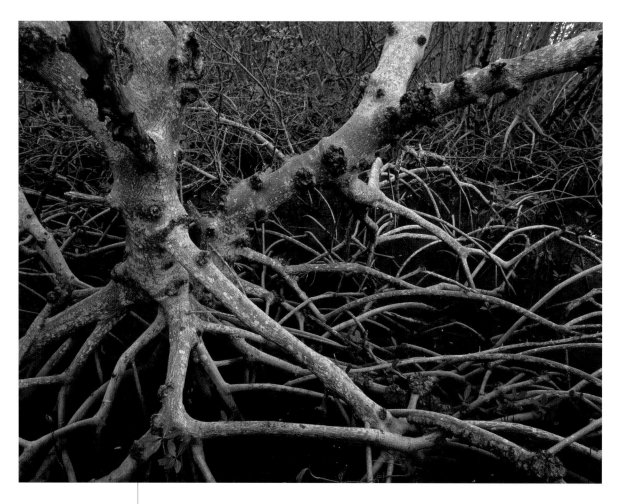

In deep shade, photographic film records ambient light in shades of dark blue. The lower the light level, the more pronounced the blue will be. These roots in a Florida mangrove swamp are so eerie they seem almost sinister, and the cold blue color is appropriate. I exaggerated the perspective with the use of a wide angle lens.

Mamiya RZ 67 II, 50mm wide angle, 2 seconds, f/32, Fujichrome Velvia, tripod.

The juxtaposition of two brilliant colors is always visually arresting. The greatest shock value occurs when the colors are non-complementary, such as in this picture taken in Papua, New Guinea. I used Fujichrome Velvia slide film here to saturate the vivid colors even more. The diffused light from an overcast sky contributed to the richness of the effect.

❧ *Mamiya RZ 67 II, 110mm normal lens, 1/2, f/32, Fujichrome Velvia, tripod.*

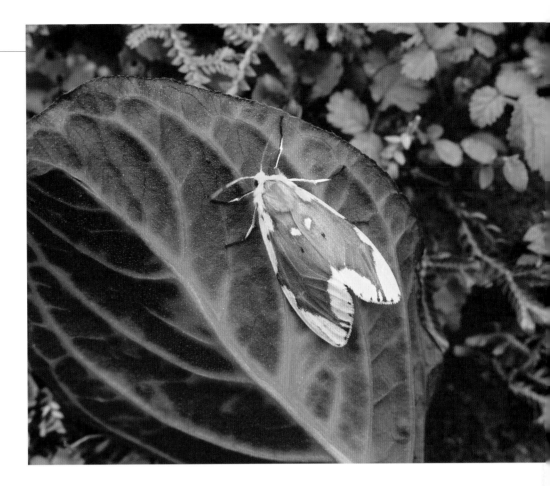

Artificial colors can be added to a black-and-white rendition of nature for the purposes of artistic enhancement. This ant was photographed with a scanning electron microscope (SEM) and recorded on Polaroid type 55 film. SEMs only reproduce subjects in black and white, so with the aid of a computer I added color to the insect but left the background unaffected. Note the remarkable depth of field characteristic of SEMs.

❧ *Scanning electron microscope, 20x enlargement, Polaroid type 55 film, Macintosh G4 computer and Adobe Photoshop.*

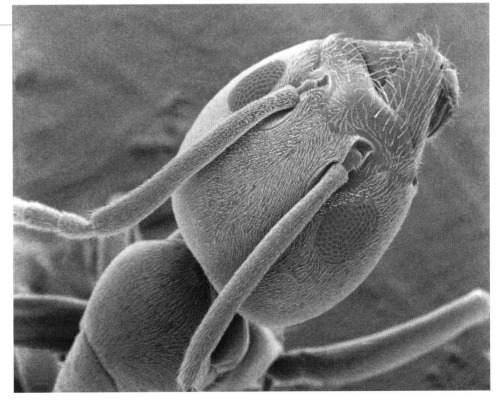

Subtlety

It is not difficult to notice brilliant color in nature — it hits you in the face. A sensational shot of a brightly colored subject is always a prize. But equally dramatic, in a very different way, are subtle combinations of color. These are less obvious, but in my opinion they are equally exciting to capture on film.

I look for subtlety in color in many different environments. Winter is one of my favorites. White-on-white conditions are often present, where the subtleties in snow, frost, ice, and a white sky produce stunning results. In contrast to the many shades of white, dark tree trunks and rock forms punctuate the monochromatic landscape.

Spring greenery also produces many opportunities to photograph subtle blends of color. Myriad tones of green can be seen growing in harmony in both deciduous and coniferous forests. Spring grasses are also beautiful, particularly in diffused light.

Another favorite subject of mine is photographing animals naturally camouflaged in their environment. The subtle blending of the animal with its environment is fascinating to witness, and the subtlety of tonalities in the composition often makes it difficult at first glance to detect the hiding animal.

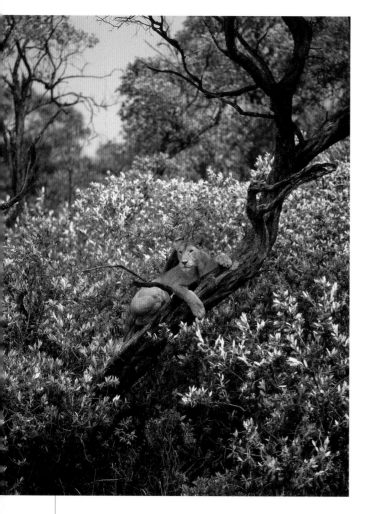

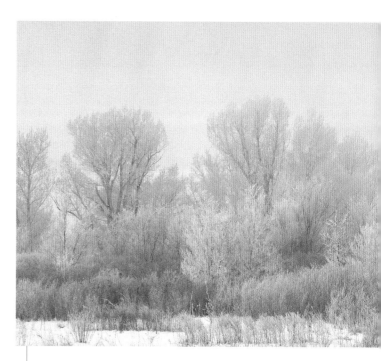

White on white is the most subtle color combination possible, and it is my favorite color theme in nature. Hoarfrost had settled on these trees in Lone Pine, California, overnight, and in the morning low fog enshrouded the entire area. The fairyland scene was magical to photograph.

❧ *Mamiya RZ67, 180mm telephoto, 1/2, f/22, Fujichrome 50D, tripod.*

As much as I love to shoot brilliant color in nature, many of my favorite shots are comprised of subtle earth tones. This photo taken in Kenya is a blend of muted greens and the tawny coat of the lion. The partially diffused sky light and the lack of rain contributed to the muted colors. Lions climb trees without skill, and it was comical watching this one find his way down.

❧ *Mamiya RZ67, 350mm APO telephoto, 1/250, f/5.6–f/8, Fujichrome Provia 100, tripod.*

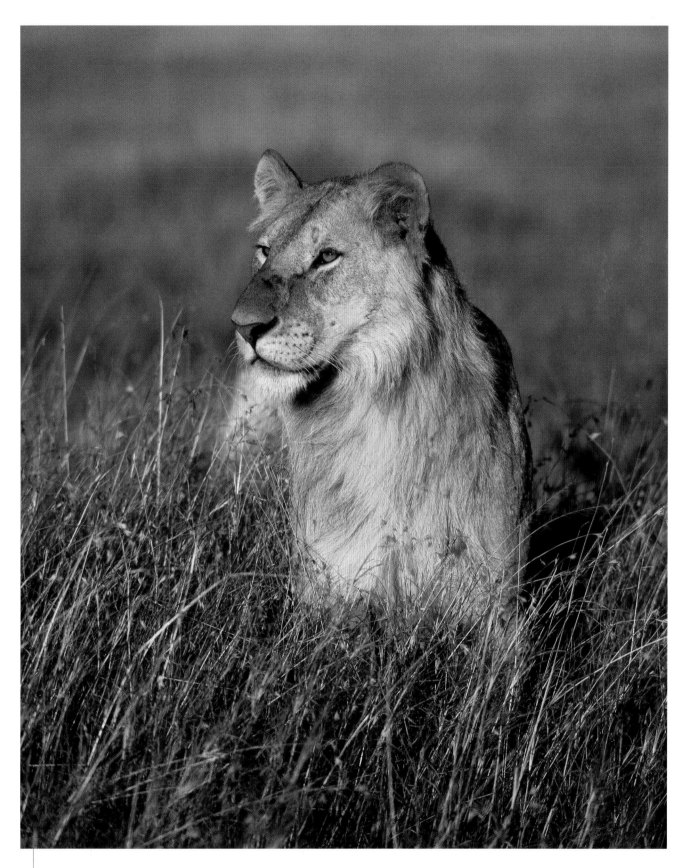

Golden sunlight transforms almost any image into one that elicits an emotional response from people. The tawny colored lion camouflaged in grass in the Maasai Mara Game Park, Kenya, is a more powerful image because it was taken only twenty minutes before sunset. An added advantage of the low-angled front lighting is that we can see the color in the eyes.

Mamiya RZ 67, 350mm APO telephoto, 1/250, f/5.6, Fujichrome Provia 100, camera rested on a beanbag in a Land Rover.

life cycles

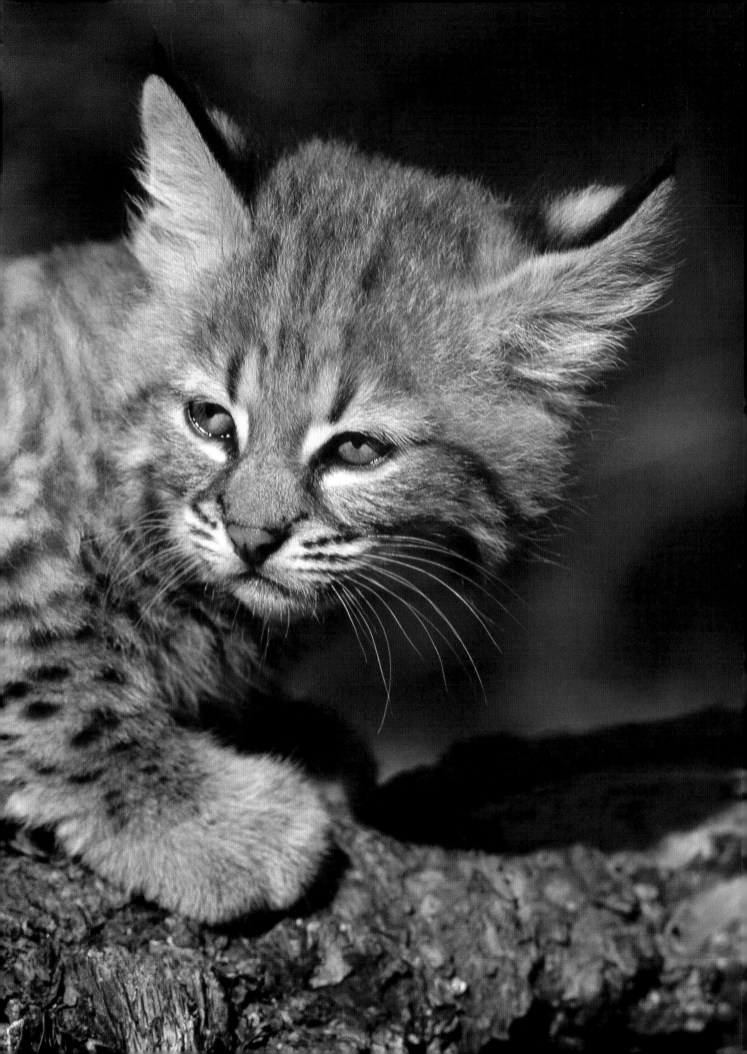

Introduction

Nature's drama is nowhere more compelling than in the life cycles that take place on a daily basis. Life-and-death struggles give photographers myriad opportunities to capture the essence of nature. At all times, and in virtually all places on the planet, these struggles are occurring. Some are very private, unnoticed by most people. Decaying bones on a remote sand dune and the emergence of a butterfly on the underside of a leaf are examples. Others are hard to miss if you're in the right place at the right time, such as a mother giraffe nursing a baby or the exquisite palette of autumn foliage in New England.

Images of life cycles offer both art and emotion. Shooting the coiled, nautilus-like form of a fern before it opens fully is like photographing art in nature, as is the intimate detail of hundreds of species of pollen. And spotting a fawn hiding in tall grass is a reward far beyond the image. It is a very touching experience, one that will become part of you for a long time. Seeking out the life cycles that surround us will produce some of your most memorable photographs.

The best way to find and capture these moments on film is to develop your skills in research. Many life and death cycles occur at the same time and place every year. Research tools such as libraries, the Internet, and natural history museums can key you into locations and particular times of the year where you can find what you're looking for. In other instances, biological researchers — such as professors and authors — can help you find cycles that relate to their field of study.

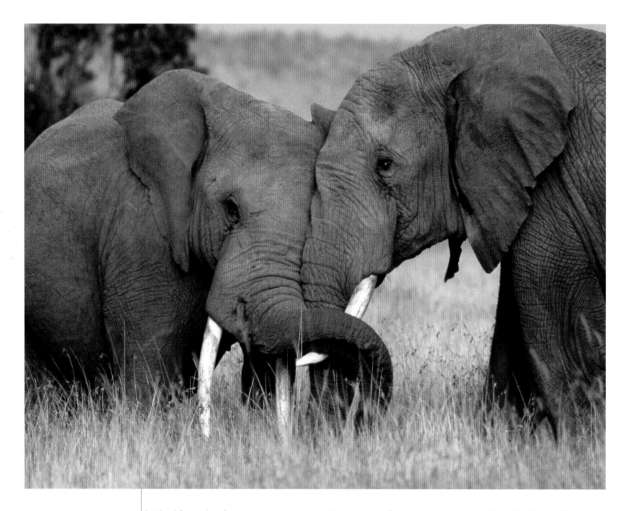

In the life cycle of many mammals, sparring is a way for juveniles to hone the skills they will need later in life to win a mate or to defend territory. I photographed these elephants in the Maasai Mara Game Park in Kenya under a dull gray sky. Many times wonderful natural events take place in poor light, while exquisite lighting conditions occur when there is nothing to shoot. When you are fortunate enough to have both great light and an exciting subject, you can really appreciate the rarity of such an event.

❧ *Mamiya RZ 67, 500mm APO telephoto, 1/125, f/6, Fujichrome Provia 100, camera rested on a beanbag in a Land Rover.*

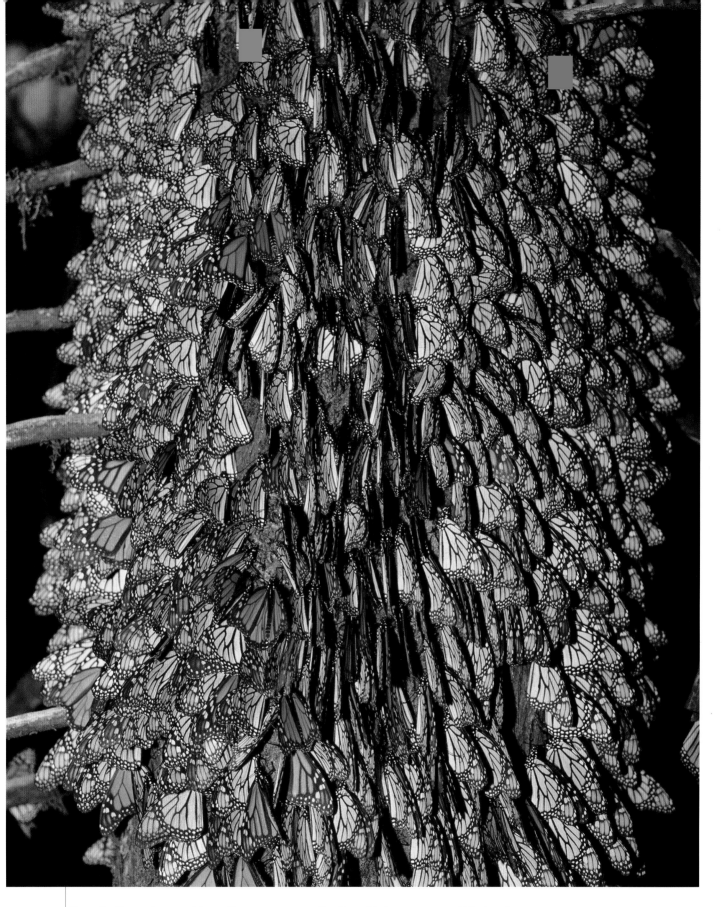

Tens of millions of monarch butterflies congregate in the Sierra Madre mountains of Mexico after their arduous annual migration from the eastern United States and Canada every September. In the overwintering sites, they completely cover the trees. Most of the insects cling to the leaves and branches in the deep shade of the forest canopy, and this required the use of a flash. Sometimes, however, I was able to find a cluster illuminated by sunlight.

🥀 *Mamiya RZ 67, 180mm lens, 1/250, f/8, Ektachrome 64, tripod.*

Seeing

To truly master the art of taking pictures, you must first realize that photography cannot capture what we see. There are several reasons for this. First, we see in three dimensions, but a photo has only two dimensions. Second, we have peripheral vision. Although we focus on an object in front of us, we are visually aware of the environment on both sides of that object. Photographs don't provide that kind of information. Third, our eyes can't do what lenses do. Telephoto lenses compress depth perception; wide angles exaggerate depth by graphically elongating it. Telephotos have shallow depth of field; thus the background behind a subject is typically out of focus. Nothing in our daily life is comparable to this.

Photography also fails in capturing what we *feel*. No photo can really convey the sensation of experiencing the Grand Canyon, for example, or even of seeing a baby harp seal. The accompanying comment most photographers make when showing their photos is, "You should have been there." They mean to say that even though the images may be great, the experience was far more powerful than mere pictures can communicate.

To witness the dramatic process of life on Earth is to experience something unique and profound in the universe. Capturing the life cycles of animals and plants on film can be beautiful, artistic, gratifying, and exciting, and it can vividly record the memory. But don't expect your camera to capture exactly what you saw or felt: If you do, you'll be constantly disappointed.

Instead, learn to think photographically. By this I mean know what a telephoto does best and look at a situation through that kind of lens in your mind's eye. At the same time, be able to previsualize the exaggerated perspective of wide angle lenses. In this way you will be able to capture artistic compositions that will remind you of the experience. That's really all that you can expect from a small piece of film.

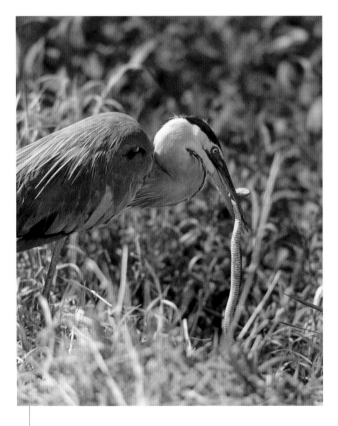

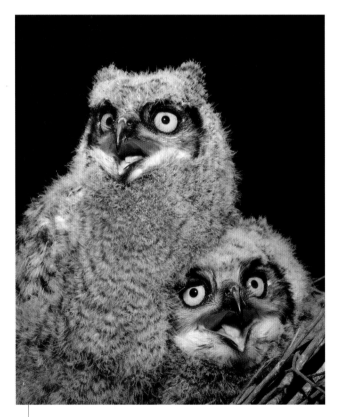

This blue heron had been seriously injured — he only had one foot — but he was successful in catching a snake in Myakka River State Park in Florida. It was a dramatic event, but unfortunately the sun was too high in the sky for good light. The artistry of the image is diminished by the unflattering illumination, but the battle between the bird and the snake makes it a compelling picture.

❧ *Mamiya RZ 67 II, 350mm telephoto, 1/250, f/5.6–f/8, Fujichrome Provia 100, tripod.*

Flash used to illuminate wildlife is rarely appropriate if your intention is to make the photograph appear natural. Too often, flash produces a black background. For diurnal animals and insects, this isn't appropriate because it implies the animal is active at night. However, with nocturnal creatures such as owls, a black background is acceptable.

❧ *Mamiya RZ 67, 250mm telephoto, 1/125, f/11, Metz 45 flash, Fujichrome 50D, tripod.*

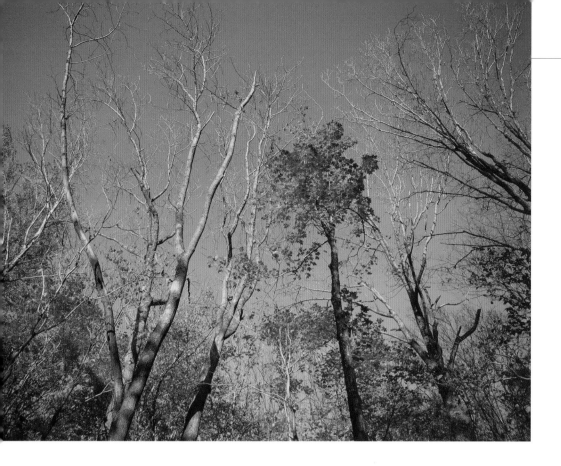

I prefer to shoot autumn foliage in diffused light so that the myriad shades of red, yellow, and orange are not adversely influenced by the harsh contrast of an overhead sun. In this photo, however, sunset lighting in New Hampshire's White Mountains attracted my eye. I liked the interesting graphic shapes of the trees and the golden light against a blue sky.

🕊 *Mamiya RZ 67, 250mm telephoto, 1/125, f/4.5, Fujichrome Velvia, tripod.*

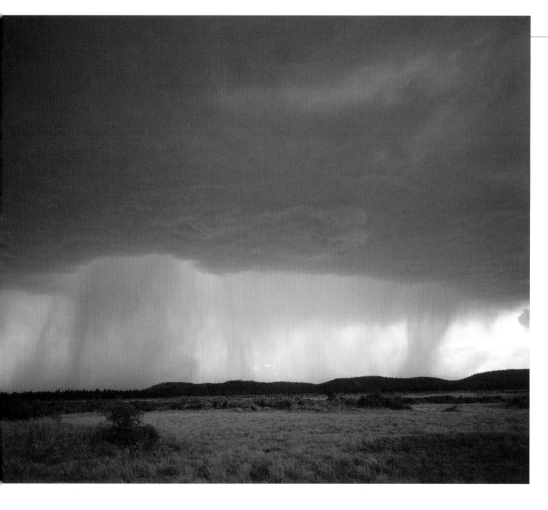

The life cycle of weather often provides dramatic moments, such as this remarkable sky in the high desert country of Oregon. Accompanying this eerie cloud pattern were dozens of lightning flashes that triggered many grass fires, but I wasn't lucky enough to capture the daytime bolts.

🕊 *Mamiya 7, 43mm wide angle, 1/60, f/4.5, Fujichrome Provia 100, tripod.*

Nature
Setups

There are many life cycles in nature that are easy to find and photograph. Spring flowers, autumn foliage, large animal migrations, unique species in the Galapagos Islands, and nesting birds are only a few. But there are thousands of species of both animals and plants that are either inaccessible to most people or that require much time, effort, and money to locate and capture on film.

There are many techniques nature photographers use to increase their stock of photos of exotic species. One of these is the nature setup. Animals, insects, or plants are purchased from dealers such as pet stores, private collectors, and mail order companies. The subjects are then raised in a natural environment and photographed to simulate the wild. The photo of the caterpillar below is an example of this. I purchased several caterpillars of the polyphemus moth and raised them at home to photograph the life cycle of this species. I have also purchased various species of butterflies through the mail (check with the local branch of state fish and wildlife department to find out if this is permitted in your area) because they were not indigenous to my home. Rather than travel across the country to shoot a few new species, I bought the eggs or caterpillars for a few dollars and was able to take some beautiful pictures with very little expenditure.

You can use this same technique for reptiles, amphibians, spiders, some birds, and many plants. Not all species will mate and reproduce in captivity, but with the proper care many do. Other resources include commercial ventures such as butterfly houses, alligator and crocodile farms, orchid growers, and game farms. Without traveling halfway around the world, you can photograph the life cycle of many animals within easy reach of your home.

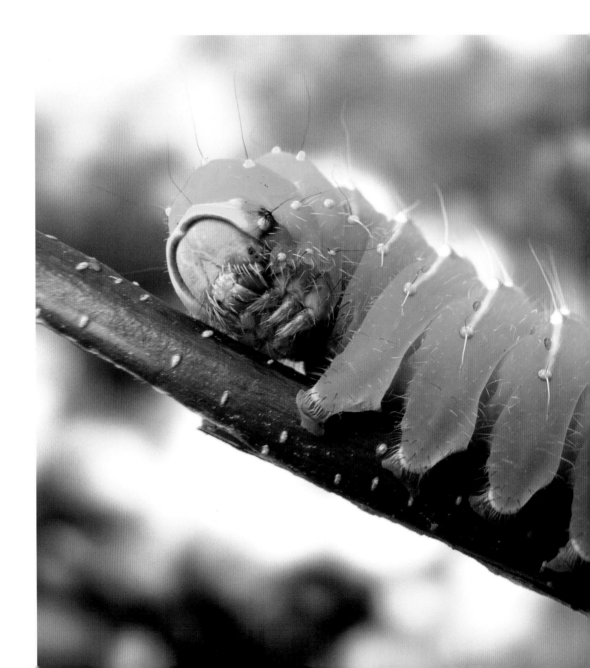

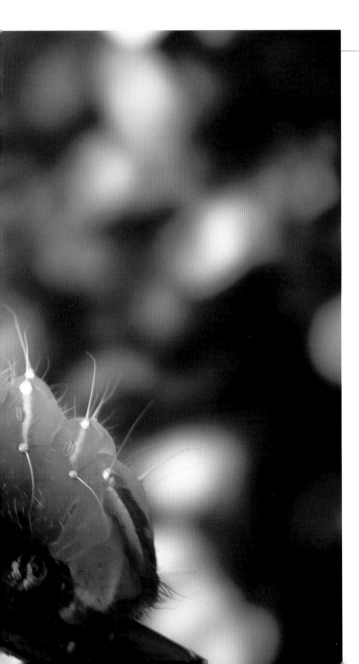

I raised this polyphemus caterpillar so I could photograph it as it grew and pupated into an adult moth. With complete control over the photographic situation, I was able to create a successful picture by placing it in front of a 16" x 20" photographic print of out-of-focus foliage. This enabled me to use a small lens aperture so that the caterpillar was completely sharp but the background remained appropriately soft. I made this photo in my kitchen.

Mamiya RZ 67 II, 250mm telephoto, Canon 500D diopter, 1/125, f/32, Zap 1000 flash unit, tripod.

To photograph life cycles successfully suggests you are intimately involved in the life of an animal or plant. You can imply a certain intimacy by choosing a viewpoint that intimates you are not just an observer, but rather that you are somehow a participant in the life of the subject.

A low camera angle does this. Shooting small subjects such as insects, small mammals, flowers, and birds on their own level makes you part of their world. The photo of a crab on page 69 is an example. Had I photographed straight downward, the orange color against black lava would be a strong graphic picture — and a successful one — but it wouldn't be intimate. You would be looking at the crab as an outside observer rather than with eye-to-eye intimacy. Most people don't expect to be invited into the world of small creatures, so when you show them this kind of view it is unexpected and visually surprising. The baby tigers on the next page provide another good example.

Looking upward from a low angle at large subjects is a useful technique as well. Shooting majestic conifers that rise to dizzying heights from the bottom with a wide angle lens gives stature and power to the trees. Large mammals such as elephants and giraffes, when photographed from ground level, make a very dramatic statement. In Kenya and Tanzania, where it is illegal (and dangerous) to leave your vehicle to photograph wildlife, many photographers shoot from roof hatches. I prefer to shoot out of the side window for a lower point of view. In some situations, I've opened the door and, using a waist-level viewer on my camera, taken pictures from an angle just above ground level. A three or four foot difference in camera angle makes a *big* difference.

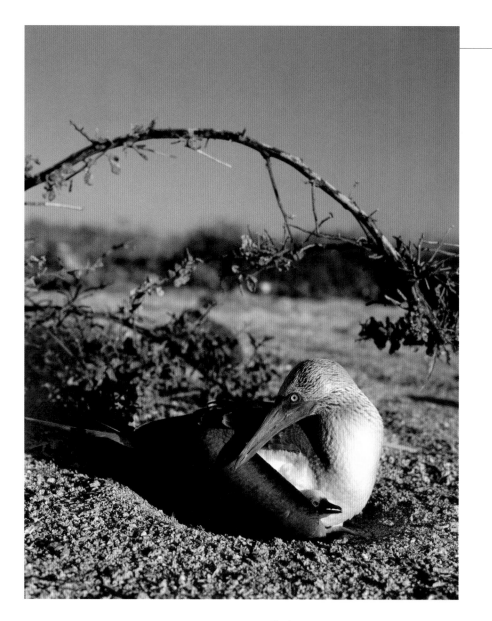

Life cycles are easy to photograph in the Galapagos Islands because the animals are so approachable. Even when the inhabitants have babies to protect, like this blue-footed booby, humans are tolerated to walk within touching distance. There are only a few places in the world where wide angle lenses can be used to photograph birds.

Mamiya RZ 67 II, 50mm wide angle, 1/125, f/8, Fujichrome Provia 100, hand held.

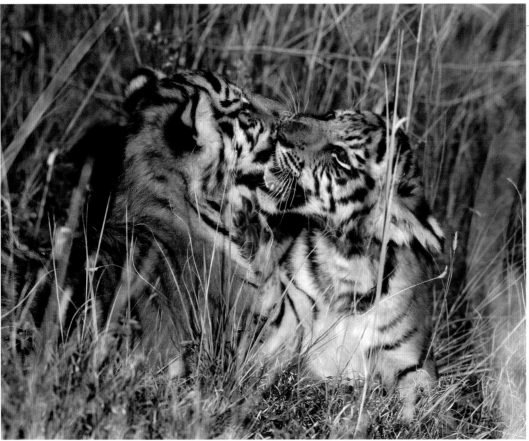

I rarely use fill flash, but sometimes the light level is too low and long shutter speeds aren't an option. My concern in using it here was the possible distracting shadows cast by the grass on the bodies of the two baby tigers. Without the additional light, though, I couldn't have taken a sharp picture of the active cats.

🐾 *Mamiya RZ 67 II, 250mm telephoto, 1/125, f/5.6, Metz 45 flash, Fujichrome Provia 100, hand held.*

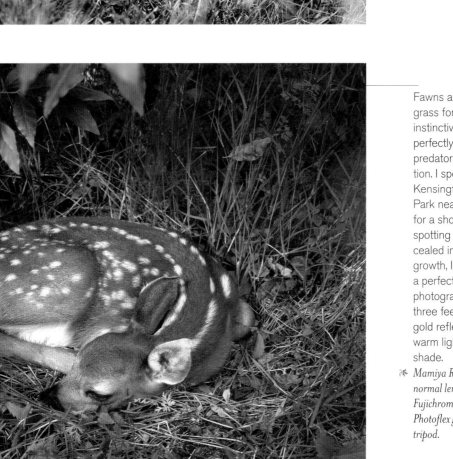

Fawns are hidden in tall grass for protection, and instinctively they remain perfectly still: It's easy for predators to detect motion. I spent three days in Kensington Metropolitan Park near Detroit looking for a shot like this. After spotting two fawns concealed in thick undergrowth, I found this one in a perfect position to photograph from only three feet away. I used a gold reflector to bounce warm light into the deep shade.

🐾 *Mamiya RZ 67 II, 110mm normal lens, 1/8, f/11, Fujichrome Provia 100, Photoflex gold/white reflector, tripod.*

texture

Introduction

Bold and subtle textures enrich the fabric of a photograph. Nature offers an endless variety of interesting and beautiful textures that you should be looking for everywhere you point your camera. Textures can entirely fill the frame, or they can simply be a portion of the composition.

Texture is enhanced and dramatized with side lighting. When a low-angled sun grazes the ground, everything from freshly fallen snow to prairie grass is illuminated in such a way that texture adds a wonderful element to the shot. The same is true for an overhead sun that illuminates a vertical cliff face. The side lighting on the rock produces a rich texture that contributes to a strong image.

Rich textures can also be seen in the hair and fur of wildlife when the sun is at an appropriate angle. This obviously cannot be planned, but an awareness of the possibility will prepare you to quickly capture it when it does occur.

Sunrise and sunset are not required for texture in nature to be dramatic, however. Even on overcast or rainy days, beautiful textures can be found on many subjects. Raindrops on flower petals, rounded pebbles on the beach, dew on dragonflies, chunks of ice on a frozen pond, and wet tree bark are only a few of the many subjects to shoot. One could spend a lifetime shooting nothing but texture in nature.

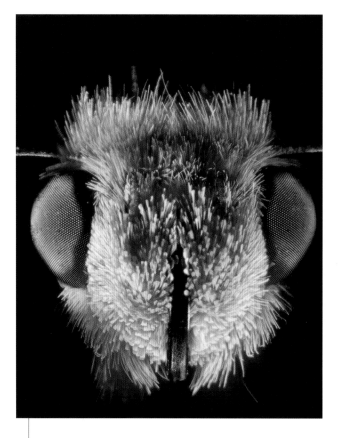

This unique ultra macro shot of a moth's face is rich in texture because I illuminated the subject with two tungsten lights, one on either side of the insect. Front lighting would have filled in the shadows and eliminated the texture.

❧ *Mamiya RZ67, 12.5mm Minolta micro lens, 10 seconds, f/2.8, tripod.*

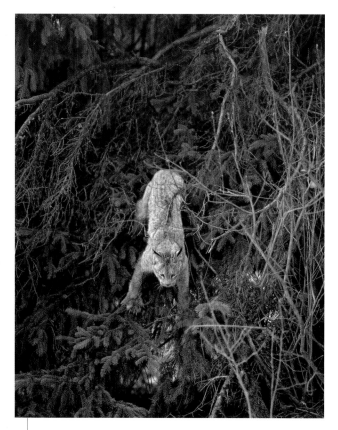

Even in muted light, this tree, with the intertwined mass of branches, is rich in texture. Despite this, however, I normally wouldn't have taken this picture because the tree is a compositional mess with no redeeming graphic quality. The Canadian lynx climbing to the ground, though, makes the shot.

❧ *Mamiya RZ67 II, 350mm APO telephoto, 1/125, f/5.6, Fujichrome Provia 100 pushed one f/stop to 200, tripod.*

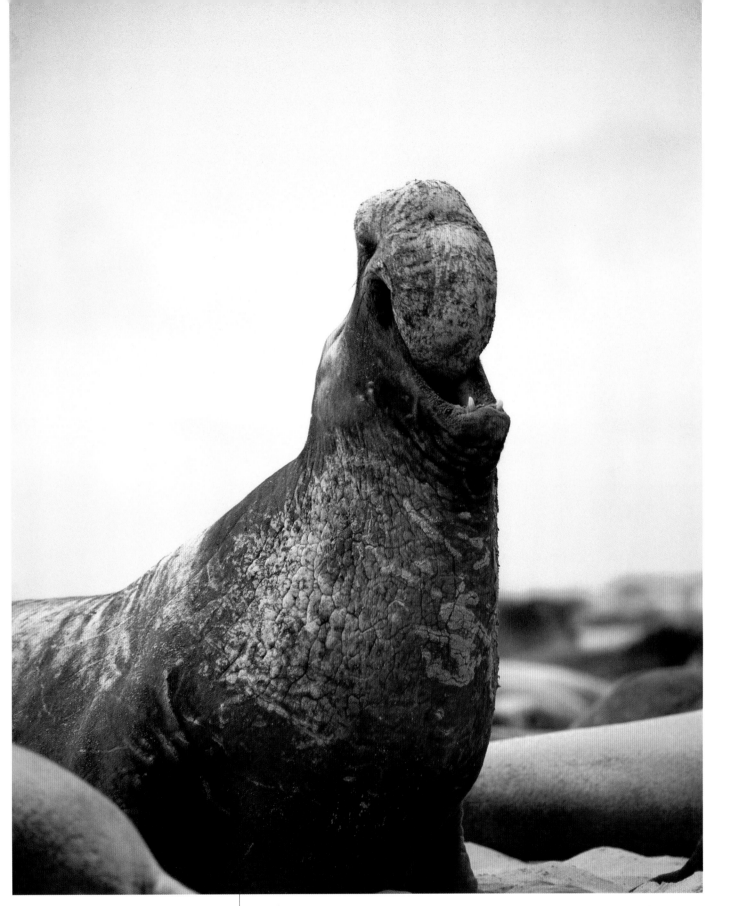

There are two defining aspects of this picture of a northern elephant seal taken in the Channel Islands National Park: the gaping mouth and the remarkable texture of the skin. In spite of the diffused light, the deep crevices in the animal's hide create the pronounced texture.

Mamiya RZ 67, 500mm telephoto, 1/125, f/8, Ektachrome 64, tripod.

Sweetlight

Even though examples of texture can be seen in diffused ambient light, the most pronounced and dramatic texture of landforms is produced by low-angled sunlight. The sun skims the surface of rocks, fallen branches, grass, flowers, and other natural objects, producing the richest texture possible.

The optimum time to capture this is within the first few minutes of the sun's appearance in the morning and just before the sun sets in the late afternoon. This lighting, when the color of the light is the warmest and the angle is the most severe, is called "sweetlight." Every minute that passes in the morning as the sun rises higher in the sky puts you further away from the magic of this lighting. Similarly, twenty minutes before sunset will not be as magical as five minutes before the sun goes down.

This is why you must disregard — at least temporarily — bodily requirements such as food and sleep if you want to get the best pictures. I don't look forward to waking up at four in the morning in the dead of winter and trekking through snow to a vantage point for a great sunrise picture. But when I do it, I've got the image for the rest of my life. Similarly, even when I'm looking forward to a hot meal in the early evening, photographic opportunities at sunset take precedence.

Great pictures in nature don't repeat themselves: You only get one chance.

The definition of this unique fissure on top of Cadillac Mountain in Maine was possible because I took this shot only minutes after sunrise. Had the sun been higher in the sky, filling the cut in the rocks with light, the unique texture and design of this image would have been diminished.

✤ *Mamiya RZ 67, 50mm wide angle, 1/2, f/32, Fujichrome Velvia, tripod.*

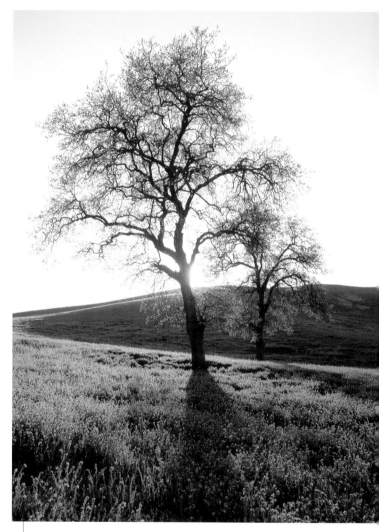

The easiest way to capture texture in nature is to shoot when the sun is close to the horizon. The light skims across the ground, creating the highlights and shadows that constitute texture. This field of spring flowers was photographed minutes before sunset in Southern California.

✤ *Mamiya RZ 67, 50mm wide angle, 1/4, f/32, Fujichrome Velvia, tripod.*

Always be aware of texture in your subjects. Composing photographs rich in texture can transform your work. This image of a marine iguana in the Galapagos Islands is dramatic largely because of the remarkable animal itself, but also because of the pronounced texture in its reptilian skin.

🐾 *Mamiya RZ 67 II, 250mm telephoto, 1/250, f/5.6–f/8, Fujichrome Provia 100, tripod.*

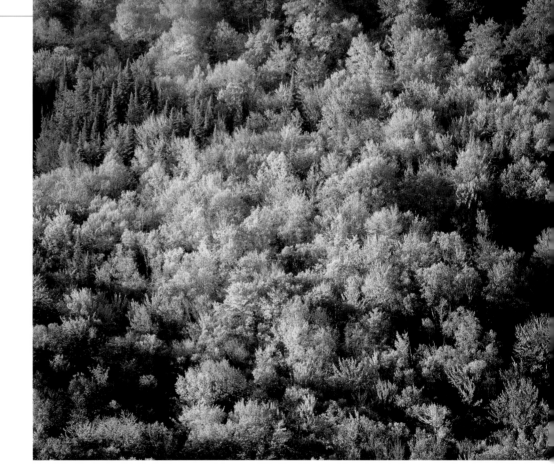

The canopy of trees 2,000 feet below me at Owl's Head in Vermont was rich in texture from the morning sunlight. When my focal point is beyond optical infinity (the distance in feet or meters where the infinity mark on the lens barrel is reached — and beyond), I always shoot wide open to take advantage of fast shutter speeds. Here the short exposure time helped produce a sharp image because the wind was fierce, and the camera was buffeted by blasts of cold air.

🐾 *Mamiya RZ 67 II, 250mm telephoto, 1/125, f/5.6, Fujichrome Velvia, tripod.*

Depth of Field

Many textural surfaces lay in a relatively flat plane. Rock faces, butterfly wings, tree trunks, a field of flowers, palm fronds, and many other subjects fall into this category. This presents a unique problem for photographers.

When the film plane in the camera is not parallel with the plane of the subject, depth-of-field problems are exacerbated. This is particularly true when telephoto and macro lenses are used. The portion of the subject's plane that is close to the camera position may be in focus, but the middle and the distant parts of the surface go out of focus quickly. This becomes a significant problem with lenses 200mm and longer and when very small objects are photographed with a telephoto macro.

You can increase the depth of field significantly when the film plane is parallel with the subject plane. If perfect parallelism isn't possible, then the camera should be angled closer to this ideal. Many times in my photo workshops I see students forget to do this, and in the critique I have to point out that their pictures lack the depth of field they might have had.

Take the time to study the camera angle from the side to make sure it is as parallel as possible to the subject's plane. It can make all the difference. Every detail in the texture you are shooting will then be as sharp as it can be.

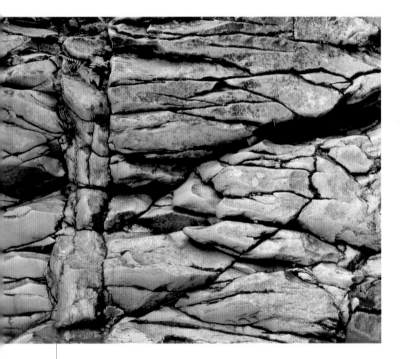

Rather than side lighting defining texture in this photo, the light and dark patterns within the rock give the appearance of a rich texture. In pictures where the detail of the subject comprises the entire composition, it's important that every part of it be tack sharp. Because this rock face wasn't perfectly flat, I used a small aperture for maximum depth of field.

Mamiya RZ 67 II, 250mm normal lens, 1 second, f/32, Fujichrome Velvia, tripod.

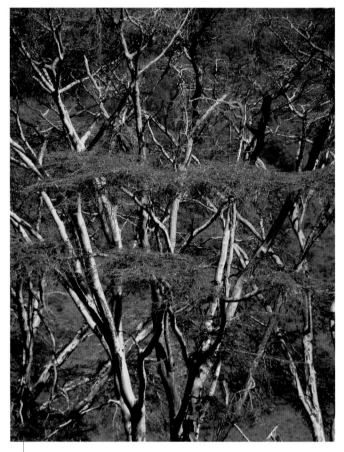

The further the subject is from the camera, the less depth-of-field problems will affect the plane of focus when the film plane and the subject plane are not parallel. This acacia tree was far enough away that the upward tilt of the camera would probably not be a factor in rendering the entire frame sharp. However, as a precaution I used a small lens aperture.

Mamiya RZ 67 II, 350mm APO telephoto, 1/15, f/22, Fujichrome Provia 100, tripod.

text Flash

I rarely use on-camera flash for nature photography. The reason this kind of lighting is not desirable is that it destroys texture. The strong frontal light fills small depressions in fur, rock surfaces, bark, and other natural surfaces that otherwise exhibit a great deal of texture. When I photographed the orchid below, I placed the flash off-camera to create texture.

Fill flash, when used judiciously, is supposed to subtly fill shadows with a small amount of light, but enough shadow detail should remain for the subject to retain its original texture. Effective fill flash (where the environment still appears to be natural) should be underexposed from the ambient by two-thirds to one full f/stop or more, depending on how subtle you want the added light to be. The exception to this rule would be when you are shooting at night or in an exceptionally dark situation, such as the jungle floor.

If you like flash photography, a portable flash can be used to side light subjects, providing the flash unit can be removed from the camera and placed off to one side. A long connecting cord permits this, as does a remote slave. In this situation, you actually control the amount of texture in your subject by the angle of the light. A 45° angle creates a moderate amount of texture; a 90° angle creates the maximum texture possible. The exposure in this instance should be predetermined by a test roll of film, or more conveniently with the use of a flash meter.

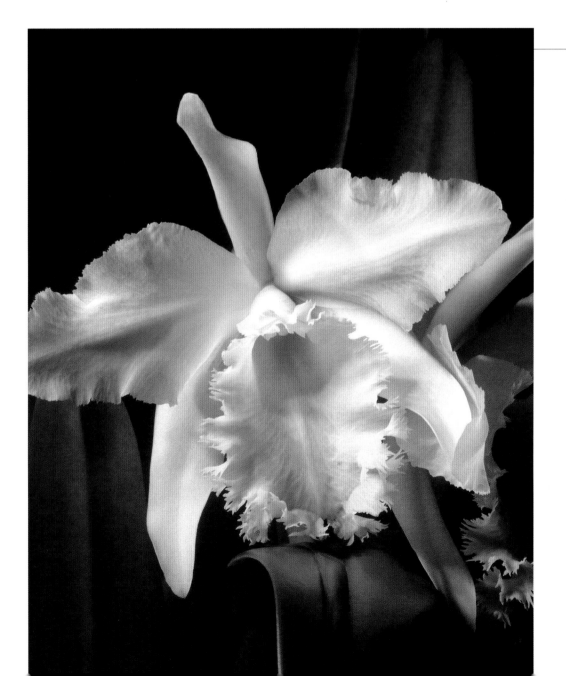

Flash can produce rich texture in a subject when the light comes from one side. If a flash unit is used on the camera, resulting in front lighting, virtually all texture will be lost. This white orchid was illuminated from above.

⚜ *Mamiya RZ 67, 110mm normal lens, 1/125, f/22, Speedotron power pack with single strobe head, Fujichrome Velvia, tripod.*

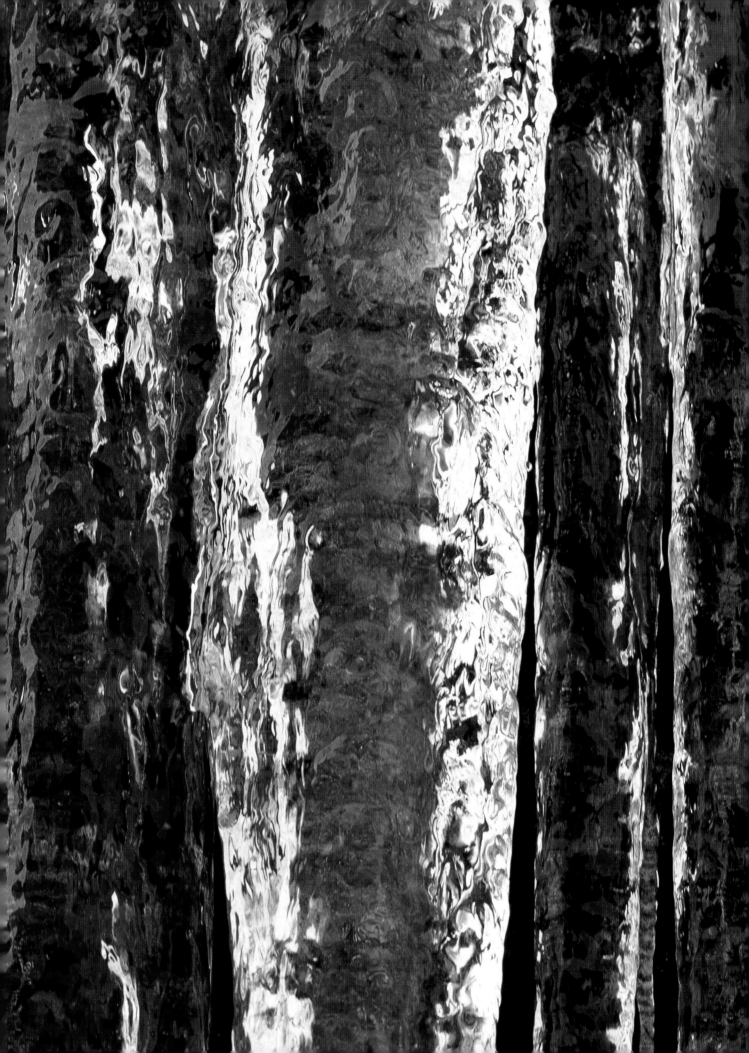

Introduction

Determining the correct exposure in the field is the most challenging aspect of nature photography. Even among professional photographers, the level of insecurity regarding exposure is amazing. A group of pros shooting together constantly ask each other what their meter readings are. No one seems confident in either the accuracy of their own meter or their visual assessment of the light.

In all fairness to both professional and amateur photographers, though, many factors can adversely affect exposure. First and foremost, meters can malfunction or they can be calibrated incorrectly. Second, light conditions outdoors constantly change, as does contrast. Third, the subject itself affects how a TTL meter reacts. Bright subjects such as snow or the sun's reflection on a lake reflect a lot of light back into the camera and will consequently cause your pictures to be underexposed. Dark subjects such as a black marine iguana on lava or a murky swamp in bayou country affect the meter reading in the opposite direction. Correct meter readings are not really difficult, however. Understanding the concepts to produce accurate exposures is within the easy grasp of everyone. The only two ideas you need to understand are that you can use a reflected meter to read a middle-toned subject, or you can use an incident meter to read the light falling onto the scene. Both of these scenarios will produce perfect exposures every time. Study the following photographs and captions and this should be made very clear.

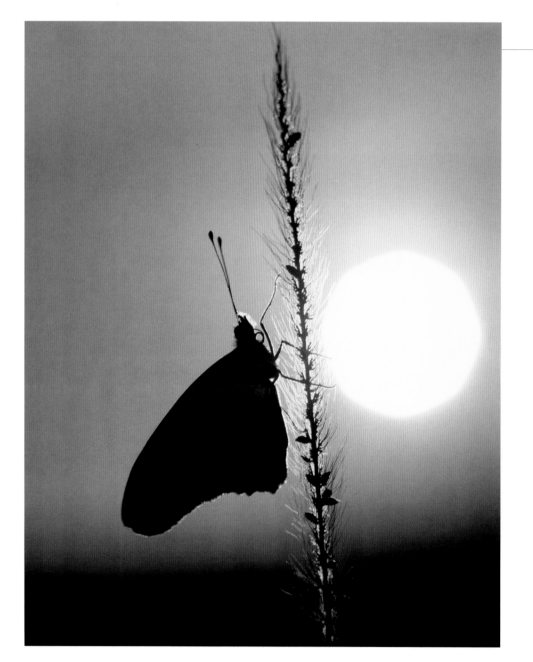

Shooting directly into the sun, especially when the sun is very large, is an impossible metering situation for any photographic meter. The sun behind this gulf fritillary, photographed in Texas, was made large purposely by using shallow depth of field (an out-of-focus sun always seems disproportionately big). I took the light reading from a mid-toned portion of the sky — away from the sun — and then used that exposure information for the shot. The only middle-gray area in the sky was the blue above me.

🦋 *Mamiya RZ 67, 127mm normal lens, 1/125, f/8, Fujichrome 50D, tripod.*

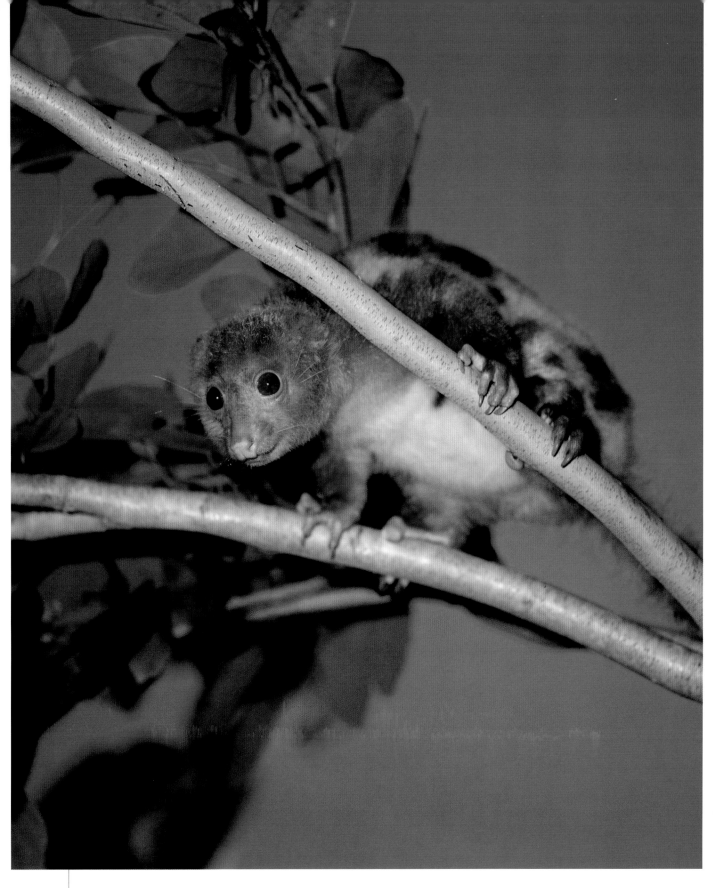

Modern 35mm cameras can automatically determine exposure for fill flash. However, if you choose to calculate exposure the old-fashioned way — with your brain — you must first take an ambient reading of the light and then set the flash to underexpose by the amount you want. In this instance, I underexposed this cus cus in Papua, New Guinea, by two-thirds of an f/stop.

Mamiya RZ 67 II, 250mm telephoto, 1/60, f/8, Fujichrome Velvia, Metz 45 flash, hand held.

Sunny f/16 Rule

What happens when your meter breaks and you're in the field without another one? Or worse, what happens when your meter is consistently giving you inaccurate readings and you don't know it? The obvious answer is that your exposures will probably be worthless.

There is a way, however, to train your eye to be so sensitive to natural light that you can make correct light readings without a meter. You may not want to do this all the time, but it is insurance should you ever have a meter malfunction. Sooner or later, it is going to happen.

I learned this technique using a handheld incident meter, but a reflected meter can be used in conjunction with a Kodak gray card. Over a period of a week, I studied light throughout the day and guessed what the exposure should be. I did this on overcast days, in bright sunlight, at sunrise and sunset, and in various kinds of shade. In each instance I tested my estimate with the light meter to determine how close I was. After seven days, I typically could get within a half f/stop of the correct exposure, and sometimes within two or three tenths of an f/stop.

I made the guesswork simple by using only one variable. In determining the exposure for every shot, there are actually three variables: shutter speed, lens aperture, and film speed. In learning how to mentally assess light, I used only one ISO (years ago, I shot Ektachrome 64 exclusively, so I used 64 ISO) and one shutter speed (I chose 1/125 of a second because for most pictures I can hand hold the camera at this speed). Only the aperture varied.

The theory is the "Sunny f/16 Rule," which states that the correct exposure for a bright sunny day with front lit subjects is f/16, and the shutter speed is the reciprocal of the ISO. If the film speed is 64, then the correct setting for a sunny day is 1/60 at f/16, or 1/125 at f/11. For cloudy bright lighting (very faint shadows), the aperture should be 1/125 at f/8, and for open shade it is 1/125 at f/5.6. Sunrise and sunset lighting are also f/5.6.

Using these numbers, you can eventually learn to distinguish subtleties in half stops and even third stops.

Lightning storms are another situation in which a light meter is useless. Lightning bolts are so contrasty that even if you had time to take a reading, it wouldn't be accurate. Correct exposures with lightning only come with trial and error. When the bolts are filling a large portion of the sky at night, I suggest opening the shutter with the camera on a tripod and using f/8 with 100 ISO film. When the lightning is several miles away, use f/5.6.
Mamiya RZ 67 II, 250mm telephoto, f/5.6, Fujichrome Velvia, tripod.

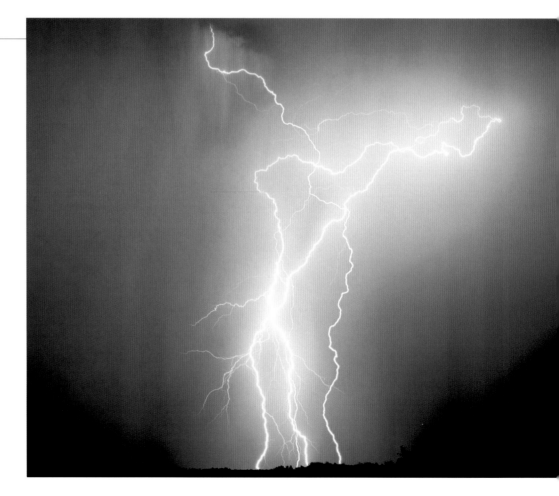

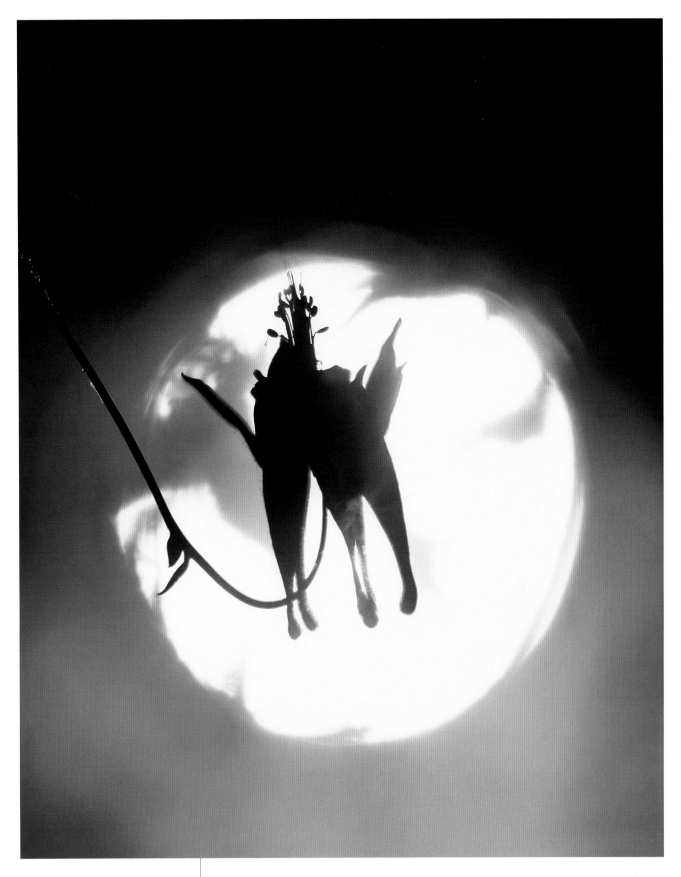

There are a few situations where it is impossible to accurately read the light with any meter. This macro shot of a columbine silhouetted against the sun was so contrasty that there was no middle gray from which I could get a reliable reading. I simply guessed at the exposure, using the Sunny f/16 Rule as a guide. Silhouettes provide some room for error.

Mamiya RZ 67 II, 250mm telephoto lens, 500D Canon diopter, 1/125, f/8, Fujichrome Velvia, tripod.

Shooting Snow

Nature photographers know that shooting on snow is problematic. The brilliant white environment causes all camera meters, no matter how sophisticated, to underexpose the pictures. Meters are programmed to make all subjects medium gray. When snow becomes gray, however, it is inappropriately dark.

Many photographic instructors teach that the solution is to open the aperture by one-and-a-third or one-and-a-half f/stops to compensate for the undesirable underexposure. I disagree with this technique as a solution. I certainly acknowledge that compensation must be made, but the exact amount can't be the same for all situations. There are too many types of snow conditions for one general rule.

For example, snow reflects light very differently under a blue sky when the sun is bright than it does in overcast conditions. When the sun is behind you, the glare on snow is not as intense as when you point the camera in the direction of the sun. Sunrise and sunset lighting are again different in terms of light reflecting off the snow back into the camera. In addition, freshly fallen snow is brighter than patchy snow that is partially melted.

The way you compose your picture is also important. How much of the frame is filled with white snow? If it is only the lower third, while the rest of the picture includes bare trees that are not covered with snow, a TTL meter may read the situation perfectly.

The solution to the snow dilemma is to know the two ways that always guarantee a perfect exposure. First, use a reflected meter to read a middle-toned object in the frame, and then use that reading for the shot. Second, use an incident meter to determine the light falling on the scene (assuming the same light strikes the meter as is illuminating the subject). Both of these methods will always work.

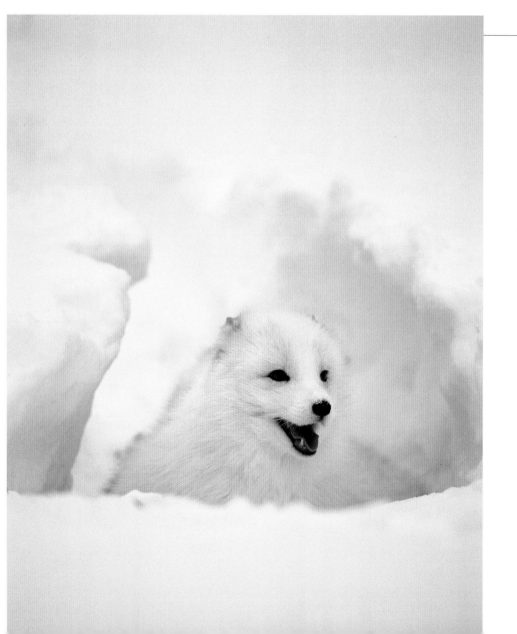

There are only two correct ways to read the light in a total whiteout. First, a reflected meter can read a neutrally toned object that you bring with you, such as a Kodak gray card or the fabric on a gray camera bag. Second, an incident meter can read the light falling onto the scene.
❧ *Mamiya RZ 67, 500mm APO telephoto, 1/250, f/6, Fujichrome Provia 100, tripod.*

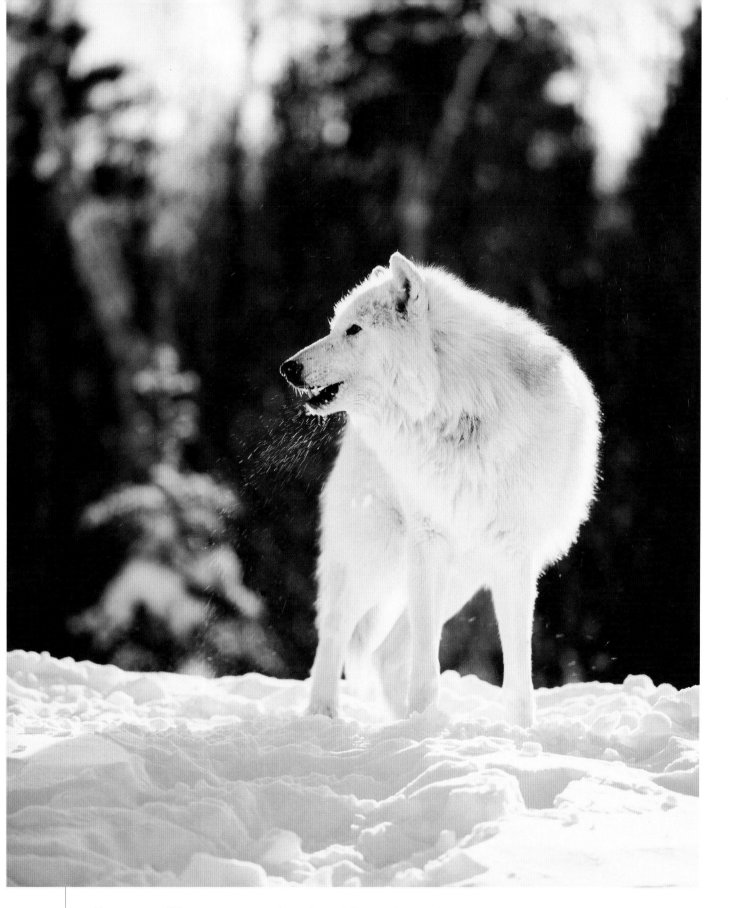

I would never trust a TTL meter — no matter how advanced the manufacturer claims it to be — to provide an accurate reading for this photograph. A white subject in the center of the frame surrounded by a white sky and white snow will be underexposed because the meter tries to make it middle toned. I used a handheld incident meter to read the light in the 45° below zero temperature.

🐾 *Mamiya RZ 67 II, 350mm APO telephoto, 1/400, f/8, Fujichrome Provia 100, tripod.*

Highlights

When we look at the world around us, the pupils in our eyes constantly open or close to vary the amount of light reaching the retina. If we go from a dark movie theater into the noon sunlight, it takes a few moments for our dilated pupils to "close down" before we can see comfortably.

Still photographs are only a single moment in time without the luxury of exposure adjustment over time. When we take an exposure reading of contrasty subjects, we must choose whether to expose correctly for the highlights, the middle tones, or the shadows for each composition. Due to the limitations of film, if you expose for the highlights, the detail in the shadow areas of the frame will be dark. Sometimes they will lose that detail and go black. Conversely, if you expose correctly for the shadows, the highlights will be overexposed, possibly with no detail. A meter reading made from the mid-tones is a compromise that may or may not work, depending on the situation.

The general rule for slide film is to expose correctly for the highlights and let the shadows fall where they may. Dark portions of a picture, or even black shadow areas, are more visually acceptable than washed-out highlights.

The reverse is true when you shoot negative film, either black and white or color. You should always give the correct exposure to the shadows.

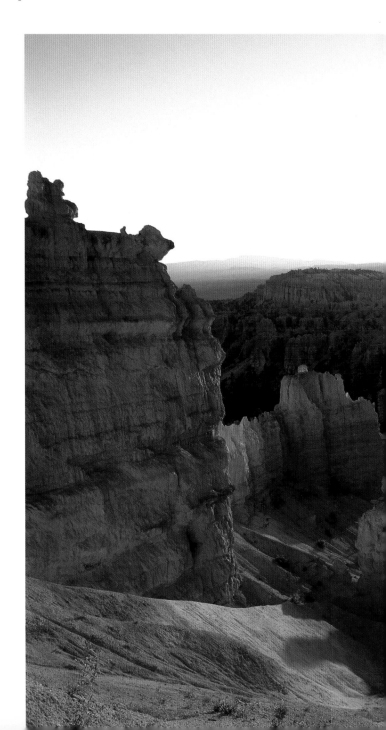

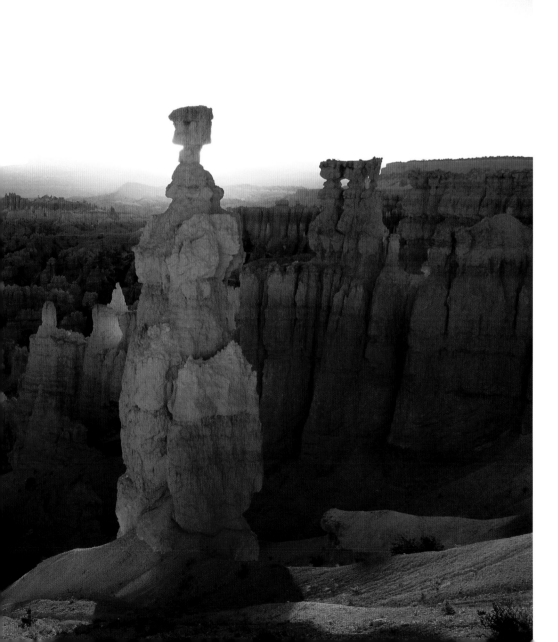

This picture of the formation called Thor's Hammer in Bryce Canyon National Park was taken at sunrise. The contrast was extreme, and I had to choose which portion of the picture I wanted properly exposed: either the sky or the detail in the unique formation. I chose the red rocks, which meant the detail in the sun and sky was lost to overexposure. Usually, with transparency film you expose for the highlights. This is an exception. Had I exposed for the sky, the rock form would have been partially or totally silhouetted.

Mamiya RZ 67, 250mm telephoto, 1/2, f/32, Fujichrome Velvia, tripod.

Handheld Meters

Handheld light meters are slow to use, they are expensive, and they add an extra piece of equipment to carry. However, they can be a lifesaver in many situations. They can act as a backup light meter in case your TTL meter fails, and they can serve as a way to periodically double-check your camera's meter for accuracy. In addition, of course, they can be used to take light readings in problematic situations.

There are two types of handheld meters: incident and reflected. Incident meters have a white plastic dome that is pointed toward the camera when a light reading is taken. This reads the light falling on the scene in front of you. The meter must be in the same light as the subject to be accurate. These types of meters are not adversely affected by extremes in contrast, or by white or black subjects. Incident meters cannot be used for taking light readings of sunsets.

Reflected meters, like the one in your camera, read the light being reflected off objects in your composition. Since white and black objects reflect light differently, readings are definitely influenced by the subjects you shoot.

If you want to purchase a handheld light meter, I recommend the Sekonic L-508 because it is capable of both incident and reflected metering in ambient light as well as flash. In the reflected mode, it has the ability to take a one-degree spot reading.

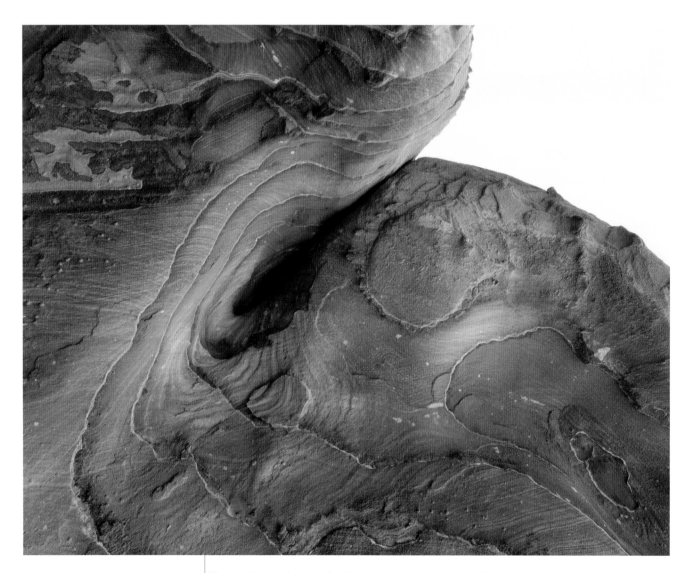

The tonalities in these rocks, photographed at the ruins of Petra in Jordan, are middle-toned, and no meter would be fooled into over- or underexposure. However, I composed the shot to include a small section of the white, overcast sky. This very bright portion of the composition might influence the camera's meter. The solution is to fill the frame with the rocks, read the light, and then use that reading for the final shot in the manual exposure mode.

❧ *Mamiya RZ 67 II, 110mm normal lens, 2 seconds, f/32, Fujichrome Velvia, tripod.*

Sometimes it's difficult to know whether bright highlights or deep shadows will influence a camera's meter. The sheen on the Mara River in Kenya was much brighter than the environment, and a TTL meter might or might not read this correctly. To solve the dilemma, I took a spot reading on the middle-toned foliage and used that data for the shot.

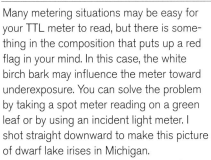

❧ *Mamiya RZ 67, 350mm APO telephoto, 1/125, f/5.6, Fujichrome Provia 100, tripod.*

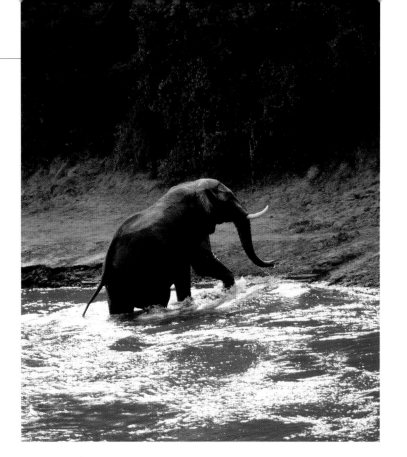

Many metering situations may be easy for your TTL meter to read, but there is something in the composition that puts up a red flag in your mind. In this case, the white birch bark may influence the meter toward underexposure. You can solve the problem by taking a spot meter reading on a green leaf or by using an incident light meter. I shot straight downward to make this picture of dwarf lake irises in Michigan.

❧ *Mamiya RZ 67 II, 110mm telephoto, 1/4, f/32, Fujichrome Velvia, tripod.*

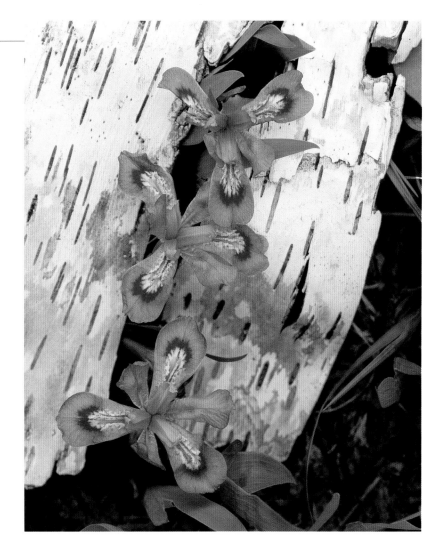

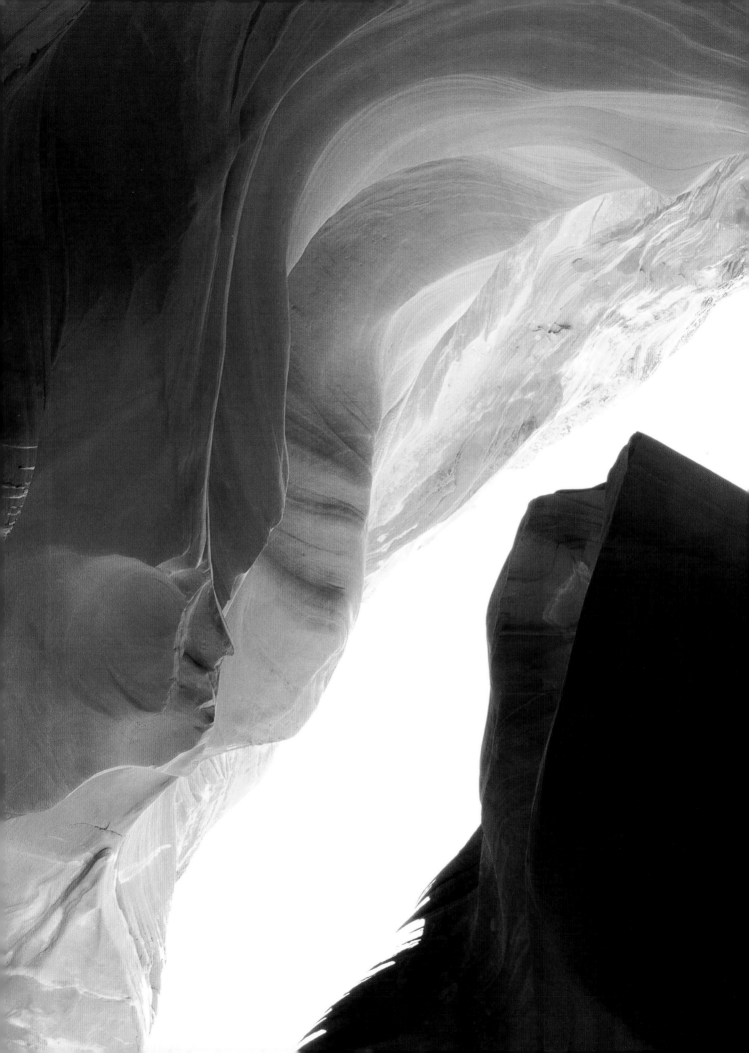

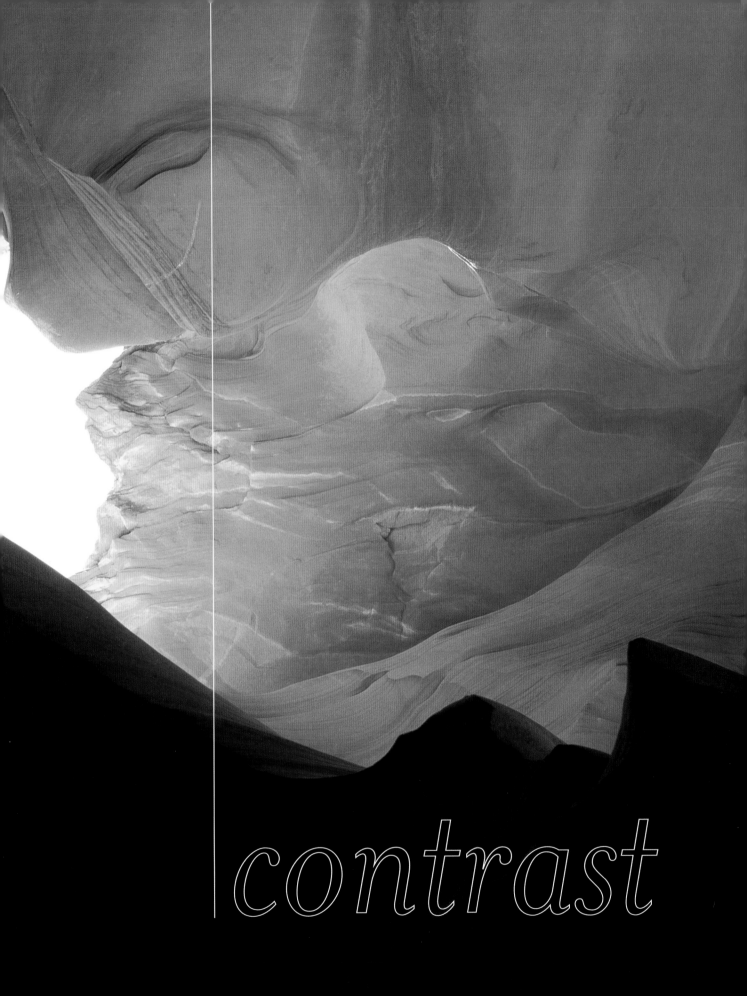

contrast

Introduction

An important tool for creating dramatic images is the use of contrast. High-contrast pictures consist of dark tones set against very light tones, exemplified by such photographs as silhouetted birds flying against a setting sun and dead leaves on fresh snow. Low-contrast images contain only a narrow range of tones, typified by trees in fog and exposures at dawn or dusk, particularly where the sky is not included in the frame. You can significantly dramatize any photograph by thoughtfully selecting the type of contrast that is appropriate for that subject. Some situations call for high contrast; others work best when captured using low contrast.

An excellent case in point is the difference between a forest in patchy sunlight and the same stand of trees in fog. The harsh contrast of sunspots and shadows is not only difficult to expose for (due to the limitation in the film's latitude), but the forest seems like a compositional mess. In addition, the strong contrast usually detracts from the ethereal beauty and tranquility of the greenery. Instead of inviting us into the picture, the overhead sunlight does the opposite. A forest enveloped in dense fog, on the other hand, is mystical and enchanting. We want to be there, enjoying the beauty and feeling the specialness of the place.

The difference between these two images, and the emotions elicited from them, is derived simply by the use of contrast between light and dark. By being aware of how your photographs are affected by contrast, you will gain an artistic advantage that will dramatize your work.

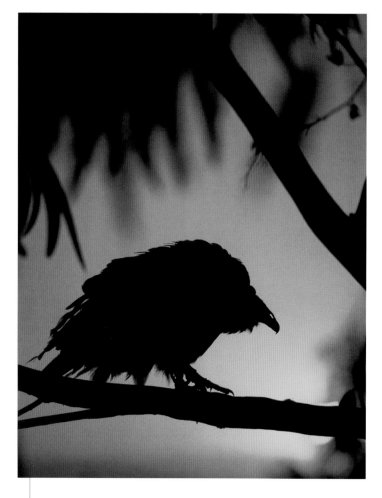

High contrast often means high drama in photography. Nothing is subtle in a silhouette against a sunset. This turkey vulture was photographed with no filter as the sun was touching the horizon. The exposure reading was taken from a middle-toned portion of the sunset away from the sun.

Mamiya RZ 67, 500mm APO telephoto, 1/125, f/6, Fujichrome Provia 100, tripod.

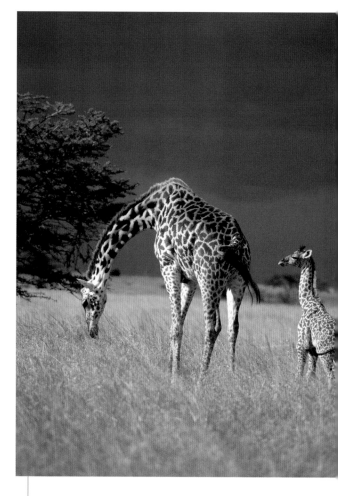

A dark sky juxtaposed with sunrise or sunset lighting on the land is perhaps the most dramatic lighting in nature, and it provides strong contrast with respect to two factors: light against dark and yellow against blue-gray. This approaching storm in Kenya was moving fast, and only minutes after taking this picture we were deluged with rain.

Mamiya RZ 67 II, 350mm APO telephoto, 1/125, f/5.6, Fujichrome Provia 100, camera rested on a beanbag in a Land Rover.

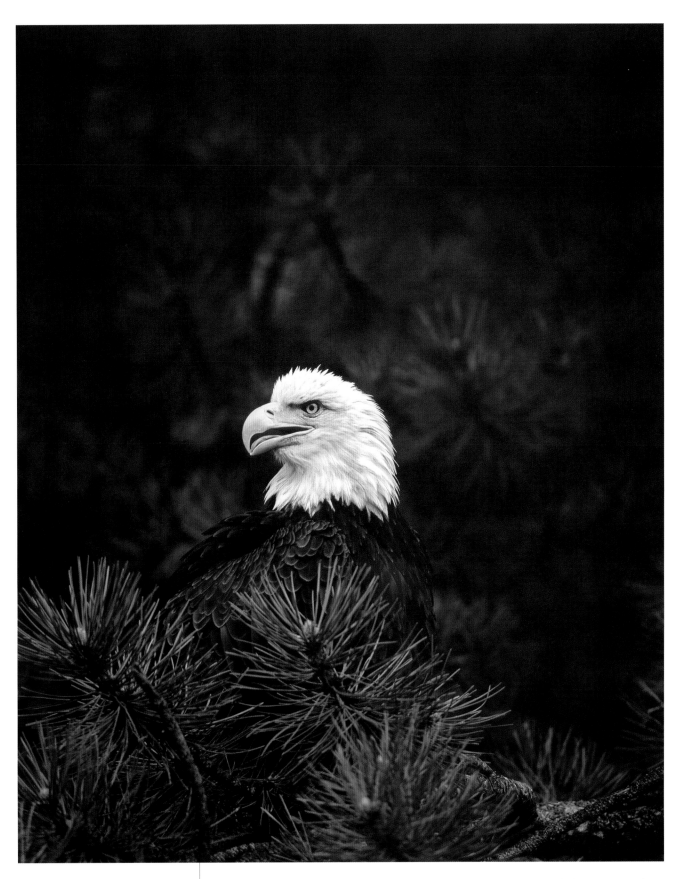

One of the dramatic ways to use contrast is when the entire composition, with the exception of a single element, is low in contrast. Here, the head of the bald eagle jumps out of the picture because the white feathers contrast with the rest of the frame.

🐾 *Mamiya RZ 67 II, 500mm APO telephoto, 1.4 teleconverter, 1/125, f/6, Fujichrome Provia 100 pushed two f/stops to 400, tripod.*

Gradient Filters

There are times when the contrast between a bright sky and the darker landscape is too great to resolve detail in both. If you expose for the sky, the land will be underexposed; if you expose for the landforms, the sky will be washed out. If you try to compromise and expose halfway between the two, both portions of the picture may be unacceptable.

The best solution is to use a neutral-density gradient filter. Half of the filter is clear and the other half is toned. The shaded portion of the filter is gray, which means the original colors in your shot will not be affected.

The filter can be used with any lens. It is rotated so that the shaded part covers the bright area of the composition to decrease only the highlights. This allows you to expose the entire photograph correctly.

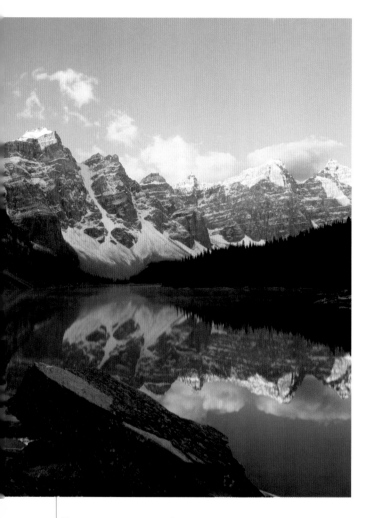

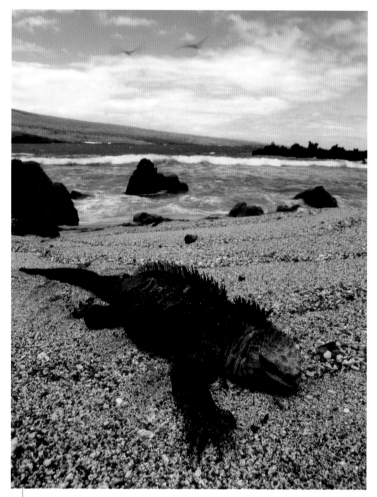

The contrast at sunrise between the bright sky and the much darker Moraine Lake in the Canadian Rockies forced me to use a neutral-density gradient filter. This darkened the sky to prevent overexposure without altering the color.

Mamiya RZ 67, 50mm wide angle, 1 second, f/32, gradient filter, Fujichrome Velvia, tripod.

Gradient filters aren't always used when the sun is shining. The day was overcast when I photographed this marine iguana in the Galapagos Islands, but the black reptile was significantly darker than the sky. If I opened the lens to accommodate the iguana, the sky would have been washed out. To solve the problem, I used a gradient filter to decrease light coming from the sky so the entire photo could be properly exposed.

Mamiya RZ 67 II, 50mm wide angle, 1/15, f/16, Fujichrome Provia 100, tripod.

Color

Combinations of color define contrast in color photography. Brilliant colors within the same frame, or a bright color next to a subject imbued with subtle shades of color, yields high-contrast images. Choosing compositions where the juxtaposition of color makes bold statements of contrast will increase the impact of your work.

The most obvious subjects for these types of pictures are wildflowers. Spring and summer are ideal times to find beautiful species of flowers in abundant quantities. Locations such as the Texas hill country near Austin in April and Yankee Boy Basin in Colorado during July are famous for wildflowers, and even in bad years, when environmental conditions produce a poor showing of flowers, you can still make great pictures with dazzling color. To boost the dramatic effect, my film of choice is the contrasty Fujichrome Velvia with its ultra-saturated colors.

Butterflies and birds are another source of color contrast in nature, particularly when they are photographed with flowers. Tropical species are usually the most colorful, and I have taken many wonderful pictures in captive situations such as butterfly houses and tropical bird enclosures. Finding and shooting these subjects in tropical jungles is extremely difficult.

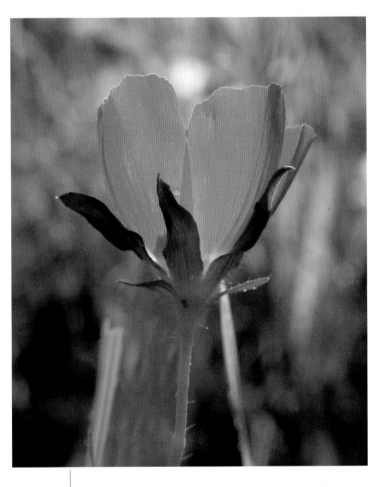

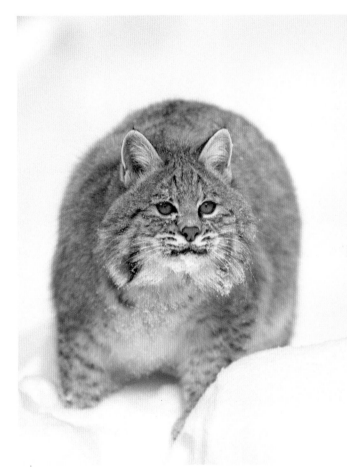

Contrast can be generated through the use of color. By selecting certain combinations of color in your compositions, you can increase or decrease contrast. Complementary colors, such as green and magenta, juxtaposed in the same shot augment contrast, as seen in this picture of a wine cup photographed in Texas. Even if the ambient lighting was soft and diffused, rather than the back-lighting you see here, this image would still exhibit dramatic contrast due to color.

🐾 *Mamiya RZ 67 II, 110mm normal lens, #1 extension tube, Fujichrome Velvia, 1/2, f/32, tripod.*

Even a subject exhibiting little contrast, such as this bobcat, makes a contrasty image when photographed on snow. However, in exposing for the middle-toned hair on the cat virtually all the detail in the snow was lost. The diffused ambient light provided no specular highlights, but the uniform white color frames the bobcat, focusing all your attention on it. There's nothing else to look at in the picture.

🐾 *Mamiya RZ 67 II, 350mm APO telephoto, 1/250, f/5.6, Fujichrome Provia 100, tripod.*

Subtlety

Some of my favorite photographs from years of shooting nature are those that are very low in contrast. Muted, somber, moody pictures can be exquisite. At first, these types of images may seem like the opposite of what you intend to shoot. Everyone wants bold color pictures with high drama — I do too, of course. But a photo that is elegant and subtle can ultimately be more powerful than one that hits you in the face with color and contrast.

I often purposely seek out weather and light conditions where I know the contrast will be low. Fog, for example, is perfect. A forest in thick fog always produces beautiful images. Especially interesting is when brightly colored subjects, such as autumn foliage or flowers, are photographed in fog. The brilliant colors normally expected from these subjects are muted, and the lowered contrast is a visual surprise that is effective in dramatizing the image.

Twilight also offers low-contrast possibilities. The directionless illumination, so flat and muted, can be used to photograph any natural subject, from landscapes to macro compositions of rock patterns. Exposures are long, so your subject must be perfectly still for a sharp rendition.

Color defines contrast in this photograph of a hillside forest in Lake Nakuru Game Park in Kenya. Myriad shades of green blend together in muted light to create a low-contrast pattern of trees. Bold, dramatic images of contrast are not difficult to recognize. You have to see with a more sensitive eye to find the subtlety.

🦌 *Mamiya RZ 67, 350mm APO telephoto, 1/60, f/5.6, Fujichrome Provia 100, camera rested on a beanbag in a Land Rover.*

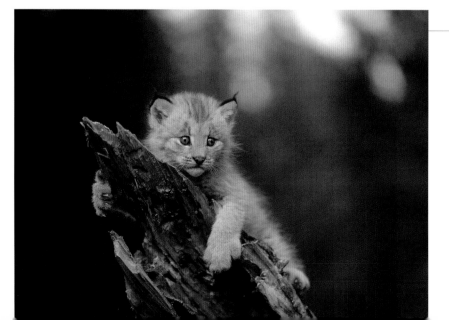

Low contrast can be surprisingly effective in creating a classic photographic image. We don't normally think of *dramatic pictures* and *reduced contrast* in the same sentence, but this picture of a baby Canadian lynx was taken in the subdued light of a deeply overcast sky. Yes, the subject is especially adorable, but the earth-toned colors in the soft light help make this a successful picture.

🦌 *Mamiya RZ 67 II, 350mm APO telephoto, 1/60, f/5.6, Fujichrome Provia 100, tripod.*

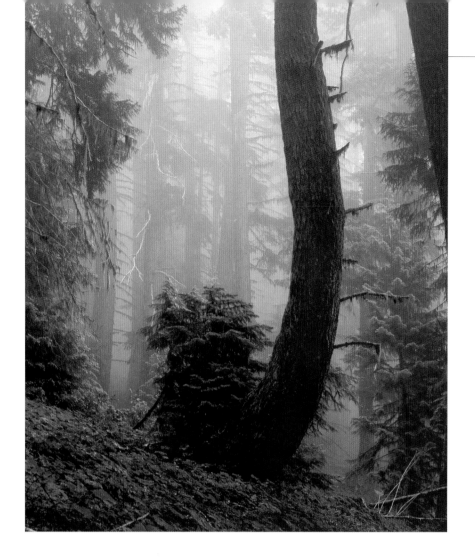

Changes in weather directly affect contrast. Thick fog, as seen in this shot of conifers on Hurricane Ridge in Olympic National Park, lowers contrast in the extreme. These type of conditions can last for many hours or only minutes. When the fog burns off, the fairyland-like environment disappears as normal contrast returns.

☙ *Mamiya RZ 67, 250mm telephoto, 1/30, f/5.6, Fujichrome Velvia, tripod.*

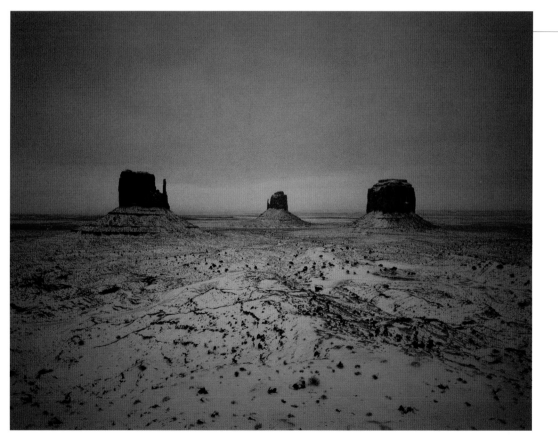

Although the light level is low at twilight, long exposures on a tripod can gather enough light for a photograph. However, the contrast is extremely low. Long exposure times cannot replace lost contrast. This shot of Monument Valley covered in snow is muted and flat.

☙ *Mamiya RZ 67, 50mm wide angle, 1/8, f/4.5, Fujichrome Velvia, tripod.*

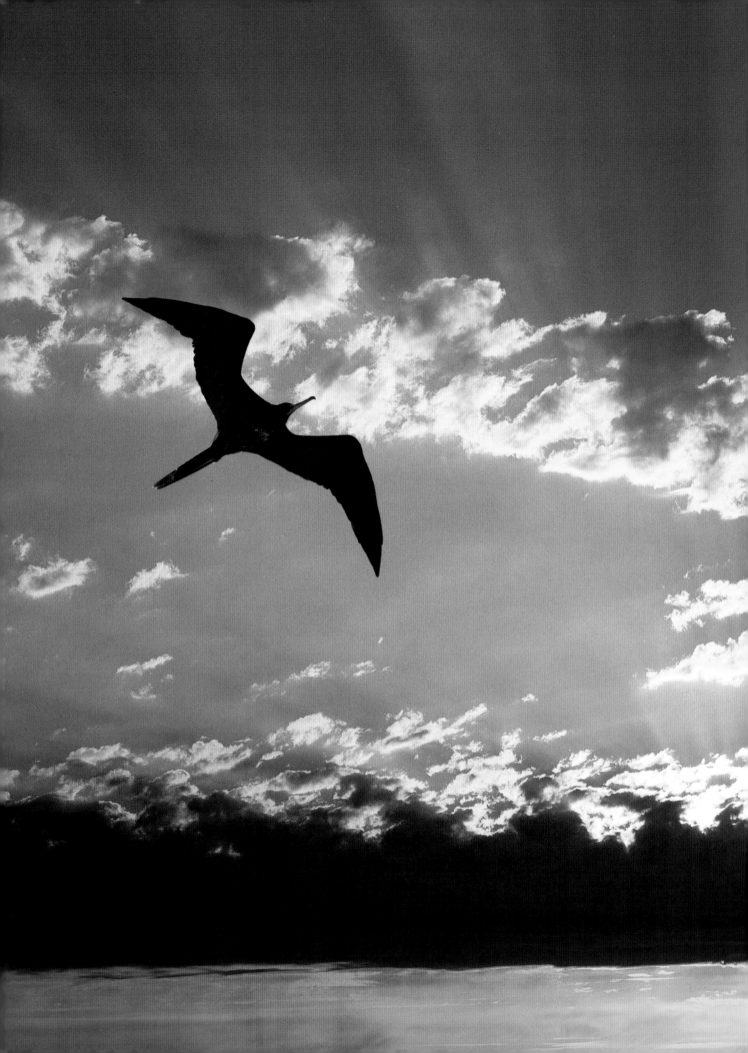

motion

Introduction

Motion in a still photograph can be implied in only two ways: The subject can be blurred with the use of a slow shutter speed, or the moving subject can be frozen in its movement with the use of a fast shutter.

It is not necessary for an animal to be moving at lightning speed in order for it to produce blur on film. For example, large birds such as egrets, herons, and spoonbills do not fly very fast, but with an appropriate shutter speed you can produce a dramatically blurred image of them in flight. Similarly, flowers blowing in the wind don't move very fast, but with the right shutter setting an artistic rendition of their movement can be produced. The shutter speed required to artfully illustrate any type of movement depends on how much blur is desired, the lens being used and the speed of the subject's movement. The range of shutter speeds I typically use is from 1/30 of a second to one full second.

Motion can also be suggested by comparing the movement of a subject relative to its background. By panning the camera with a running animal, for example, the animal will be relatively sharp but the background will be significantly more blurred. This technique is superb for capturing the drama of movement in nature.

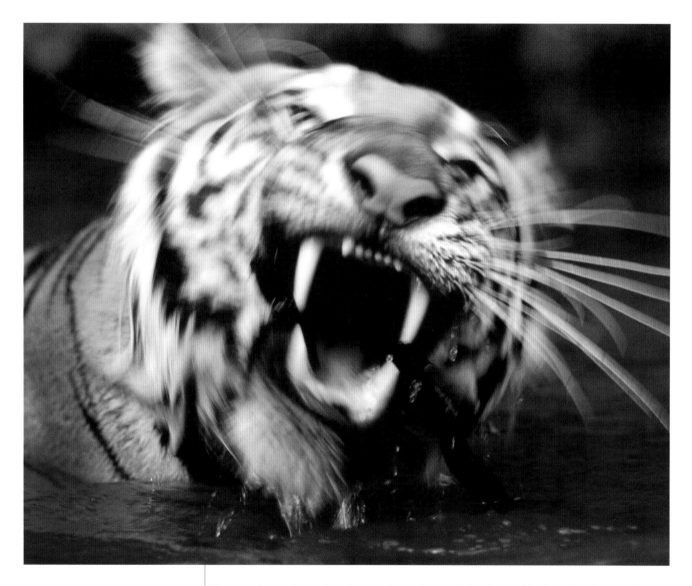

There are times when a sharp image of a moving subject is impossible due to low-light conditions. Even though I may want to freeze movement in the frame, there's no way it can be done without resorting to very fast film, which I don't like to use because of poor color saturation and flat contrast. Sometimes, however, the blurred image works, despite my original disappointment. The blur of this Siberian tiger suggests ferocity and power.

𓃢 *Mamiya RZ 67 II, 500mm APO telephoto, 1/30, f/6, Fujichrome Provia 100 pushed one f/stop to 200, tripod.*

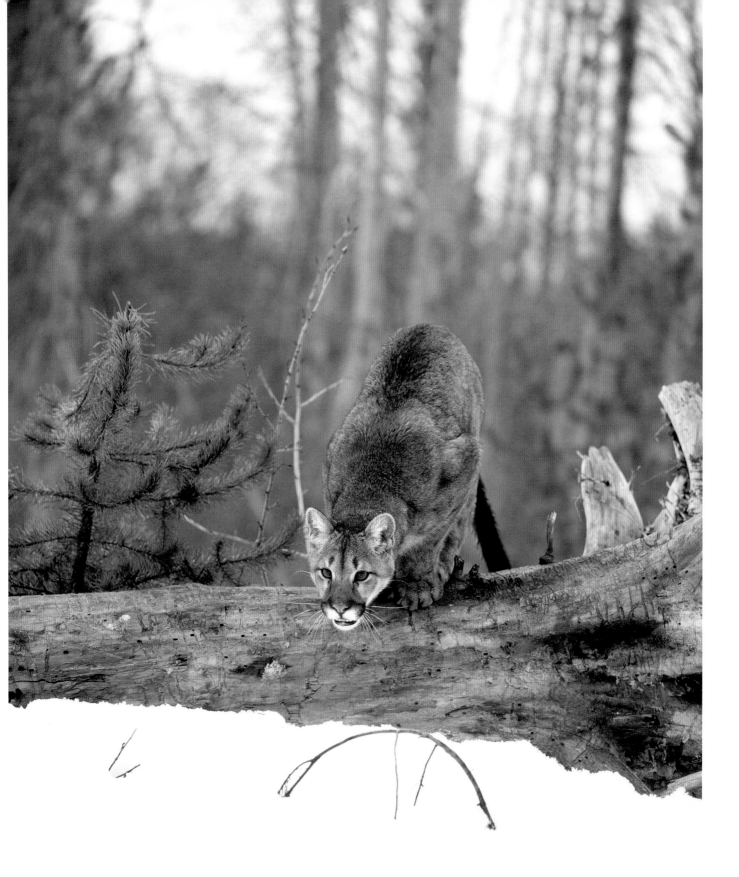

Kinetic energy is motion itself, but potential energy is motion about to happen. Everything about this picture of a mountain lion suggests motion, yet the cat is perfectly still. The muscular tension is about to explode and the taut face is focused on the target, and in this anticipation there is a sense of motion.

Mamiya RZ 67 II, 500mm APO telephoto, 1/125, f/6, Fujichrome Provia 100, tripod.

Shutter Speeds

Two groups of shutter speeds are used to imply motion in a still photograph. Fast shutter speeds freeze movement, rendering with great clarity every detail in the action; long exposure times blur movement. The faster the shutter speed, the more guarantee you will have that the fastest motion will be sharp. The longer the exposure, the more abstract a moving subject will become.

The lens you use will affect how the chosen shutter speed freezes or blurs the image. Telephoto lenses, for example, cover a narrow angle of view. Moving subjects appear to cover more distance in a shorter time in a telephoto than in a wide angle lens. Wide angles include such a large angle that motion seems to slow down relative to the background. Therefore, 1/60 of a second shutter speed renders a moving subject differently with a 300mm lens versus a 24mm lens in the 35mm film format. Depending on the speed of the subject, the telephoto will show significant blur, while the wide angle lens may show only slight blur or perhaps no blur at all.

To freeze most moving subjects, from blowing leaves to a darting fox, the minimum shutter speed should be 1/250 of a second when you are using a telephoto. For objects that move very quickly, like wings of small birds and falling water, use at least 1/500. With a wide angle lens, 1/125 of a second can be used for most action, unless the moving subject is very close to the camera position. In that case, use a minimum of 1/250.

Blurring a moving subject also requires different shutter speeds with different lenses. To blur autumn foliage blowing in the wind with a telephoto, 1/8 of a second is sufficient, while 1/4 will totally abstract the leaves. With a wide angle lens, I would use at least 1/2 second but usually one full second, depending on the strength of the wind and the distance from the subject to the camera position.

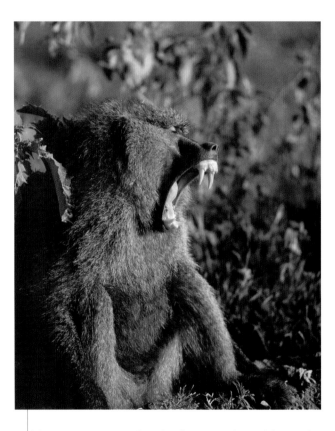

Movement in an animal or plant begins, peaks, and then ends. A slower shutter speed can be used to freeze motion if you shoot at the instant the action peaks. At this moment, there is very little movement in the subject. This baboon in Kenya made an aggressive display in response to my driver yawning.

❦ *Mamiya RZ 67, 250mm telephoto, 1/125, f/4.5, Fujichrome Provia 100, camera rested on a beanbag in a Land Rover.*

Moving water is a classic subject for long exposures to suggest motion. This waterfall was photographed in North Cascades National Park in Washington. The low light permitted a one-second exposure. Had each water drop been frozen with a fast shutter speed, the effect would have been less artistic.

❦ *Mamiya RZ 67 II, 250mm telephoto, 1 second, f/32, Fujichrome Velvia, tripod.*

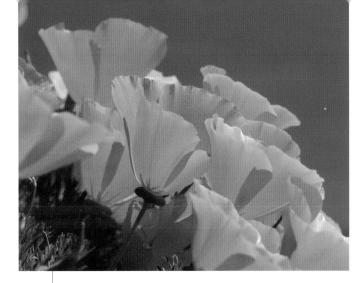 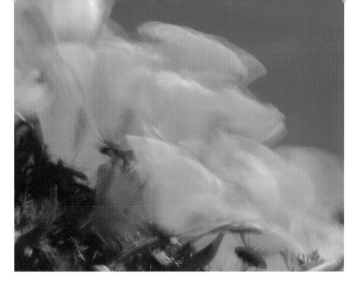

The only difference between these two pictures of California poppies is shutter speed. A light wind moved the small flowers gently, but a fast shutter speed was able to freeze the movement. Using a one-second shutter speed, however, I captured a very different type of image. In order to use a long exposure in bright sun, I had to use a polarizing filter on my lens to reduce the light by two f/stops.

🌼 *Mamiya RZ 67 II, 250mm telephoto, #1 extension tube, 1/125, f/8, Fujichrome Velvia, tripod. The blurred image has the same data, except the exposure was 1 second at f/45 with a polarizing filter.*

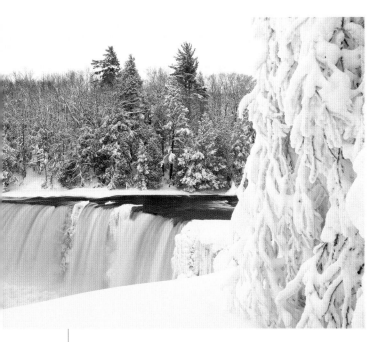

The juxtaposition of blurred movement in an otherwise sharp environment is one of my favorite techniques. In this shot of Tahquamenon Falls in the Upper Peninsula of Michigan I used a long exposure time for two reasons: to increase depth of field and to create blur in the falls. Because a wide angle lens was used, the waterfall appears smaller in the frame, which in turn required a longer exposure to reveal movement in the water.

🌼 *Mamiya RZ 67 II, 50mm wide angle, 1/2, f/32, Fujichrome Velvia, tripod.*

Notice how the water drops are frozen in this shot of a roseate spoonbill, but the wings are blurred. The fastest shutter speed on the Mamiya RZ 67 is 1/400 of a second, which is fast enough to freeze some types of motion but not others. To make this shot, I spread the tripod legs out parallel to the ground to compose the photograph from the lowest angle possible.

🌼 *Mamiya RZ 67 II, 500mm APO telephoto, 1/400, f/6, Fujichrome Provia 100, tripod.*

Follow Focus

A swiftly moving land animal or bird is very hard to keep in focus as it moves across your view, and even more difficult if it moves toward or away from you. There are three techniques photographers use to follow focus.

1. Autofocus. In the last few years, Canon and Nikon in particular have produced remarkable autofocus systems that are extremely fast. They can focus on a subject in a fraction of the time a person can do it manually. Objects moving perpendicular to the lens axis are easy to keep in focus, but fast-moving subjects that are coming toward the camera are an "iffy" situation.

 The major downside is that when the autofocus sensor loses contrast (the center of the frame is a single tone, with little delineation between light and dark), the autofocus strives to find the correct point of focus, and in those precious moments you've lost the ability to render the image sharp. Imagine a black bear on a field of snow running toward the camera. As long as the autofocus sensor can read black against white, the bear will be sharp. When the animal comes closer and fills much of the frame, the sensor may only see black. The focus will then go back and forth, seeking contrast.

2. Manual focus. Focusing by hand is challenging, but possible. You must be very familiar with your gear, and as you follow focus try to stay ahead of the animal as it moves. Shoot many frames using a motor drive during the movement, hoping to get one or two sharp pictures.

3. Preset focus. This technique is often used when an animal or bird is coming toward the camera. Prefocus in front of the movement and take the shot the instant the subject reaches the focal point. With a motor drive of five frames per second or faster, you have a very good chance of getting one sharp frame. If you have only a single shot, as I do with the Mamiya RZ, then your chances aren't great, but it is indeed possible. I've done it many times (of course, I've also thrown away a lot of film because the subject wasn't sharp).

When a telephoto lens pans across a background very fast, the result is a horizontal blur. At the same time, if the camera is following a speeding subject such as this cheetah, the subject is less blurred than the background. Most of the implied motion in the animal comes from the action of the legs rather than the movement of the camera. This differential creates a very dynamic image.

✻ *Mamiya RZ 67, 350mm APO telephoto, 1/60, f/5.6, Fujichrome Provia 100, hand held.*

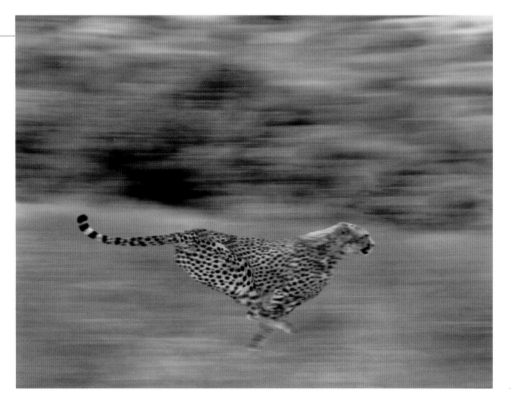

Panning a moving subject is one of the best ways to imply motion in a still photograph. These roseate spoonbills were photographed at Myakka River State Park, florida, in low light, so I was forced to use a long exposure. I turned a negative situation into a positive one by creatively blurring the large pink birds.

🐾 *Mamiya RZ 67 II, 500mm APO telephoto, 1/2, f/22, Fujichrome Provia 100, tripod.*

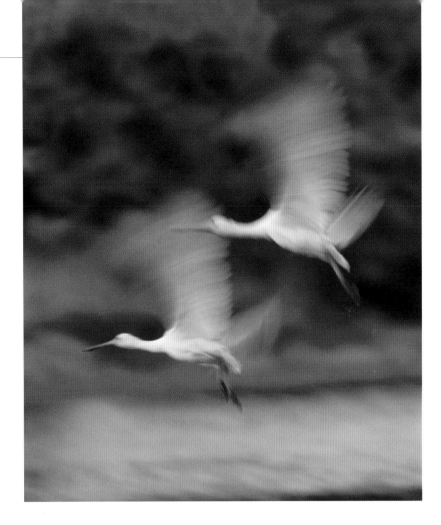

In 35mm cameras, autofocus is an invaluable tool. However, with monochromatic subjects such as a black wolf, the contrast necessary for autofocus to function properly may be absent. This is particularly true when your telephoto fills the center of the frame with a single color. Be careful to monitor whether or not the contrast in your shot permits you to focus automatically. Unfortunately, the Mamiya RZ doesn't offer this option.

🐾 *Mamiya RZ 67 II, 500mm APO telephoto, 1/400, f/6, Fujichrome Provia 100 pushed one stop to 200, tripod.*

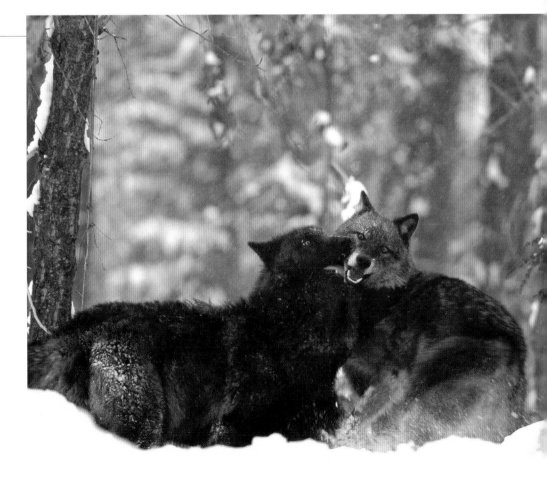

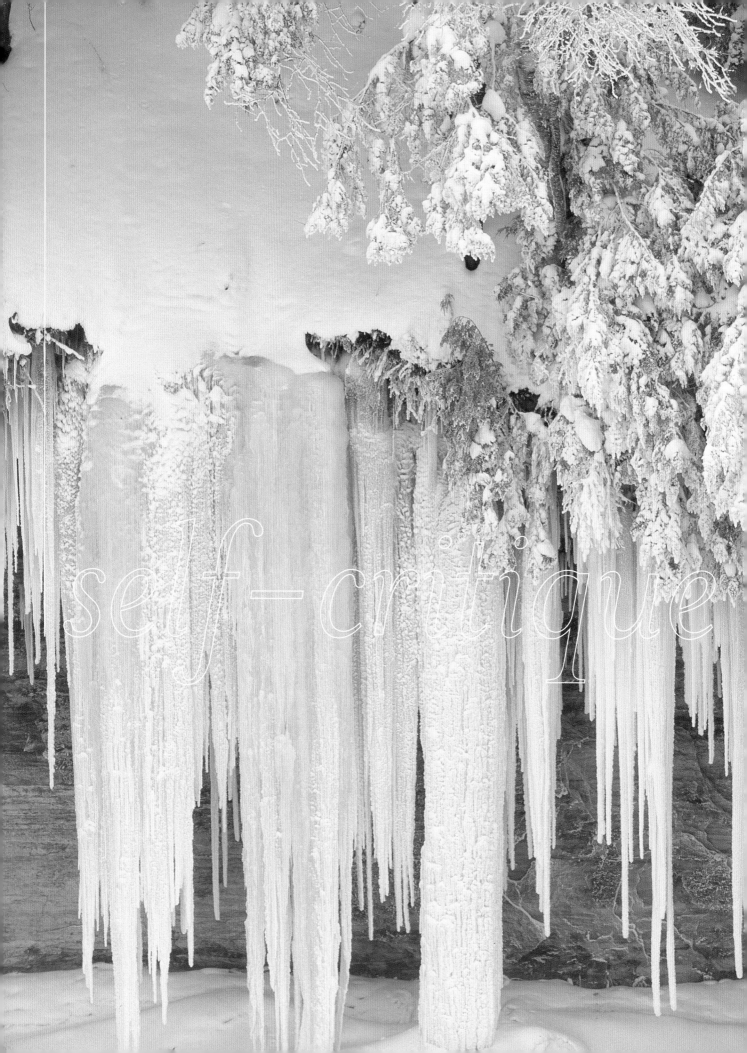

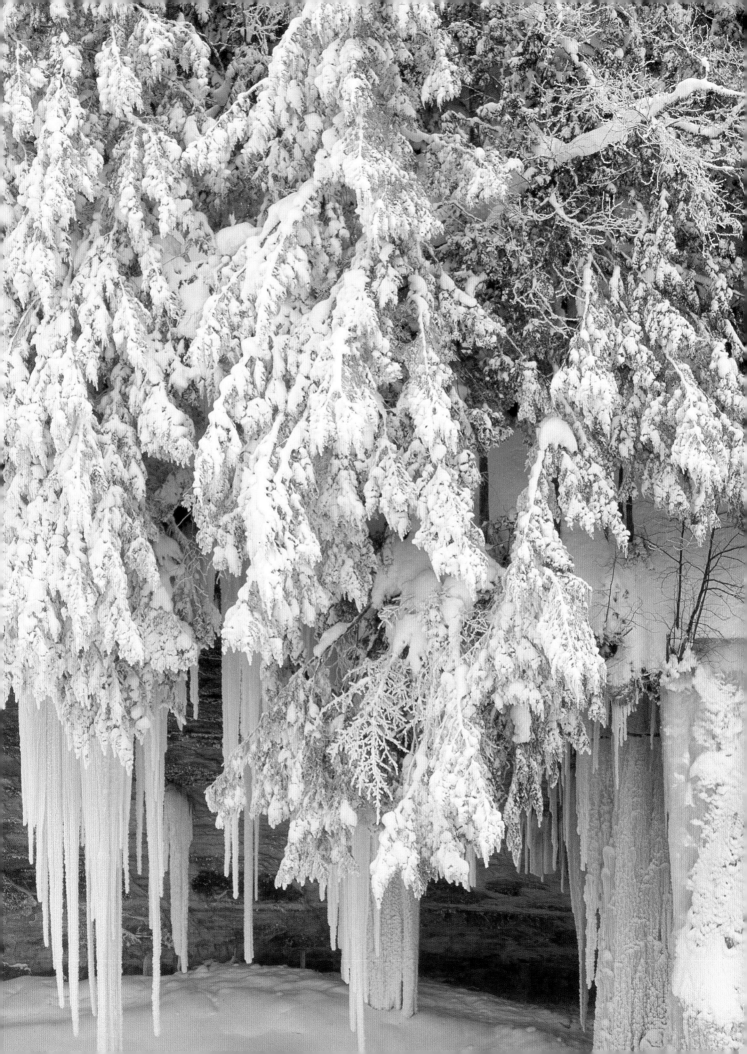

Introduction

I often critique the work of photographers who take my workshops and seminars. I have done this for many years, and I always ask the group before we begin whether they want me to be honest or nice. They always laugh knowingly and ask for honesty, but I'm convinced they don't really mean it. Egos are too fragile for an honest assessment of their photography. If a picture has no redeeming value, what am I supposed to say? "Gee, nice try, but this shot is really a total waste of film"? Or perhaps "Just don't quit your day job" would be appropriate.

Here's another important question: Should I judge their work against the highest standards, against top nature photographers? Or should I use the familiar curve, where photo students are judged against each other? If I don't use the highest standards, how can anyone really learn to take great pictures?

I think a majority of people wants me to be somewhat honest but mostly nice. And that's what I do. In this chapter, however, I'm going to critique my own pictures with no tiptoeing around a fragile ego or possibly hurt feelings. I know what's good and what's not, and I have no problem admitting it about my own work. I take a lot of pictures that are beautiful and that please me a great deal, and I take a lot of shots that are not so good. In fact, sometimes I'll ask myself, "What was I thinking when I took this?"

The photos that follow are not total failures, but they all have something wrong with them. None have been published before because of the flaws I discuss below. Most amateur photographers know when a shot is terrible, but they often don't know what the problem is when the shot is pretty good but not great. I hope this chapter helps you analyze your own work honestly and with a professional's eye.

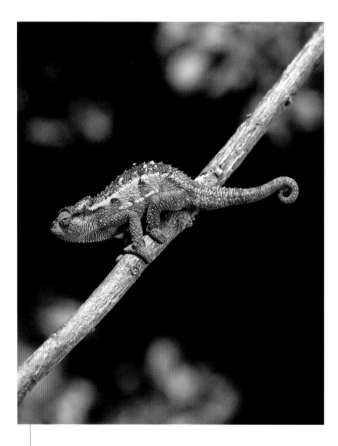

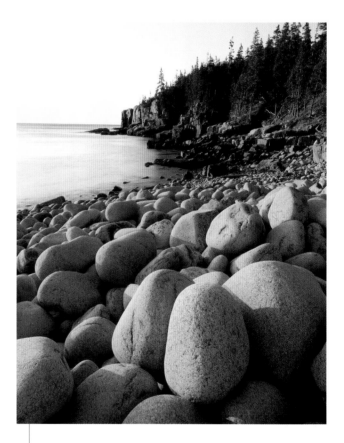

This chameleon was photographed in Tanzania on the rim of the Ngorongoro Crater. I had asked a couple of the hotel staff if they could find some chameleons in the brush, and within five minutes they brought me four of them. The out-of-focus background is good, as is the body position. But the perch I used doesn't look natural. Diagonal compositional elements are good, but this one seems too perfect.

🐾 *M amiya RZ 67 II, 250mm APO telephoto, 1/60, f/11, Fujichrome Velvia, tripod.*

I did everything right in taking this picture in Acadia National Park, Maine — sunrise lighting, wide angle dramatic perspective, and the subject matter is classically beautiful. The natural colors on this particular morning, however, are terrible. The sky is washed out, the warm-toned lighting on the trees looks muddy, and the atmospheric haze dulls everything. Even the richness of Velvia didn't save this shot. I would never show this picture to a client.

🐾 *Mamiya RZ 67 II, 50mm wide angle, 1/2, f/32, Fujichrome Velvia, tripod.*

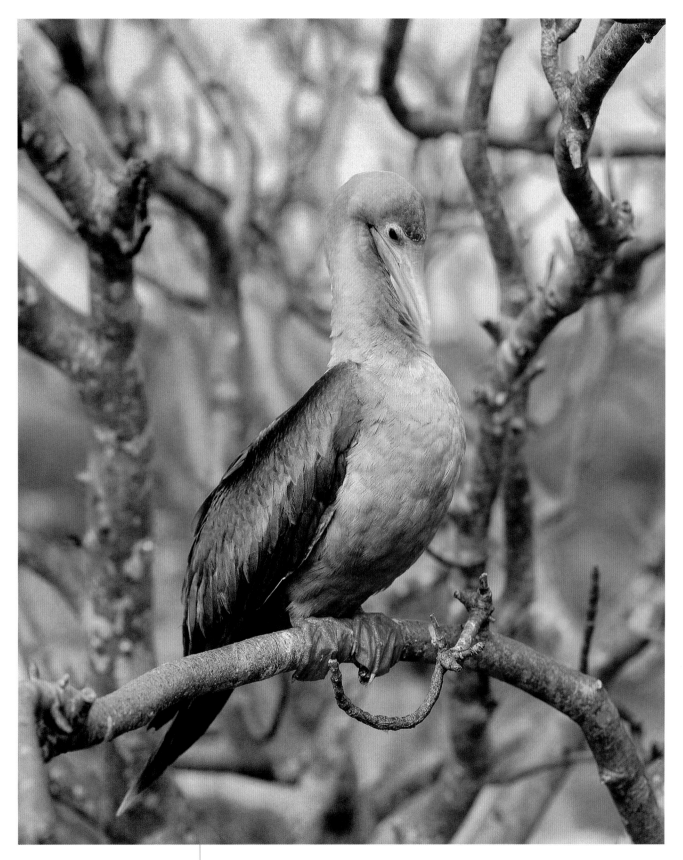

I took this shot of a red-footed booby in the Galapagos Islands with a normal lens. I couldn't back up any further because of the restriction to stay on the trail, which meant I couldn't use a long lens. The background is a tangled mass of branches that take attention away from the subject. Had I been able to use a long lens, the problem most likely would have been solved. I like the picture of the bird very much, but the background is distracting.

Mamiya RZ 67, 110mm normal lens, 1/125, f/5.6, Fujichrome Provia 100, tripod.

Honesty

In the beginning of my career, I learned to critique my own work by comparing it to those photographers whose work I admired. I used many sources, from photography magazines to Sierra Club calendars and fine art photography books, to search for excellent work. If I was interested in improving my shots of flowers, for example, I would place my images side by side with professional macro photography and compare.

I might deduce, for instance, that mine weren't close enough, that I had left too much dirt or unattractive foliage in the shot. I would then ask myself, how do I get closer? Maybe I didn't have enough depth of field, or my lighting was harsh and contrasty. What light did the professional use? Perhaps the individual flowers I had chosen weren't perfectly formed, and the ones published were flawlessly designed by nature. The next time I took pictures of flowers, then, I tried to improve on each of these factors.

If you don't compare your work to the best possible imagery, you will be striving to be mediocre. It takes many years to develop the artistic and technical maturity necessary to be a top photographer, and improvement comes in small steps. But you must be honest in your assessment of your photography or else the self-critique is pointless.

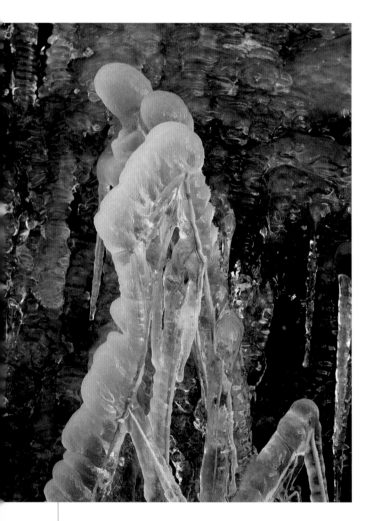

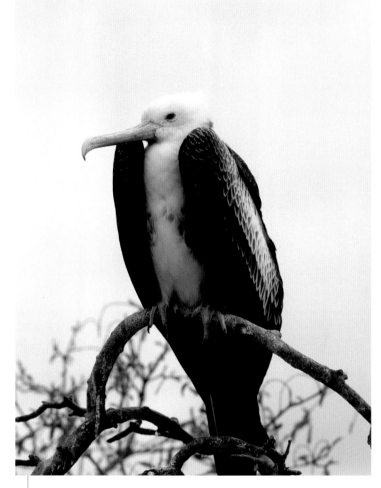

This was a nice try. The ice-covered grass photographed in the North Cascades National Park, Washington, was in deep shade, and the blue color appeals to me. But the graphics are not strong enough to make this a winning shot. The form of the ice and the dried grass is not compelling in any way.

🦋 *Mamiya RZ 67 II, 110mm normal lens, 1/2, f/22, Fujichrome Velvia, tripod.*

This frigate was photographed on an overcast day in the Galapagos Islands. The white sky doesn't bother me, because the color scheme in this picture is so muted it's almost mono-chromatic. The offending element is the tangle of branches behind the bird. A lower camera angle should have been used to eliminate the branches from the composition.

🦋 *Mamiya RZ 67 II, 350mm APO telephoto, 1/60, f/5.6, Fujichrome Provia 100, tripod.*

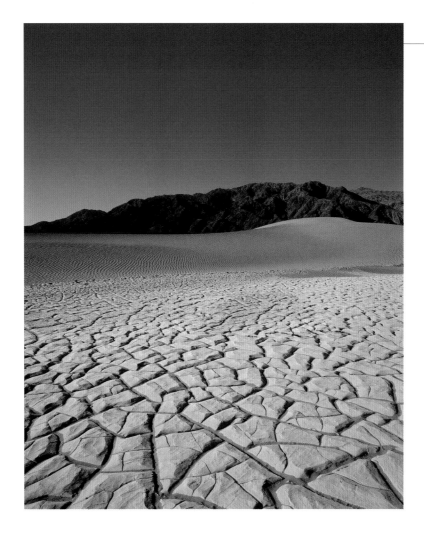

There are two things wrong with this shot: The midday lighting is unflattering, and the sky is uninteresting. Had a low sun skimmed the ground with yellow light and had sunrise or sunset clouds created a palette of color above the distant mountains, this would have worked.

🙰 *Mamiya RZ 67, 50mm wide angle, 1/15, f/22–f/32, Fujichrome Velvia, tripod.*

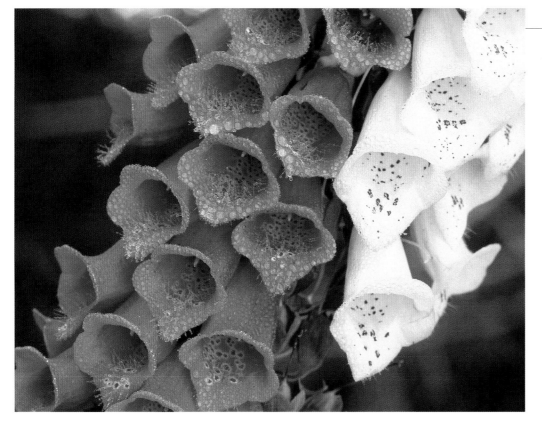

These white and magenta foxgloves photographed in Oregon are juxtaposed beautifully, but I didn't use my depth of field preview button. There is an out-of-focus, horizontal branch in the upper left portion of the picture that I find distracting. This isn't a major flaw, but nevertheless it annoys me.

🙰 *Mamiya RZ 67 II, 250mm telephoto, 500D Canon diopter, 1 second, f/22, tripod.*

When you critique your success or failure at arriving at the proper exposure for each roll of film, keep in mind that the only way to really know how accurate you are is to shoot slide film. It doesn't matter which brand or ISO you work with, but transparencies are developed the same way every time. There is no variation, and no lab technician influences your exposures.

Negative film, on the other hand, can be deceiving to analyze. It is true that all negative film is developed in the same C-41 chemistry with a consistent time and temperature procedure, but the prints from the negatives can be altered in many ways. If the original negative is too light, for example, both a machine and a custom printer will adjust accordingly to provide a well exposed print with the proper color saturation. Sometimes, however, a photo lab tries to balance a contrasty scene and gives you a poorly exposed print. Your original may be correctly exposed, and judging from the print you might deduce that you made a mistake.

It is for this reason that you should not judge your exposures from prints. Reading negatives is an acquired skill, but assessing slides is easy. If the slide is too light or too dark, you'll know there was a problem with the exposure.

This caracal, an East African cat, was photographed in patchy light in late morning. This is a very contrasty situation and rarely produces an acceptable picture. I came close here, but the highlight on the cat's body overpowers the subtle light on its face. Since the face is the most important part of the picture, this image can't be considered an acceptable shot.
❧ *Mamiya RZ 67 II, 500mm APO telephoto, 1/250, f/8, Fujichrome Provia 100 pushed one stop to 200, tripod.*

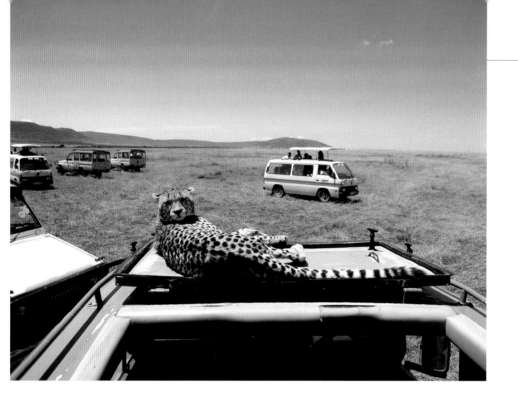

This is a snapshot: It has no artistic merit at all. I never take snapshots with my Mamiya RZ, but this was such an unusual situation in Kenya that I couldn't resist. However, the high midday sunlight is terribly harsh, the horizon is in the middle of the frame, and other safari vehicles are distracting in the background.

🕸 *Mamiya RZ 67, 50mm wide angle, 1/250, f/8–f/11, Fujichrome Provia 100, hand held.*

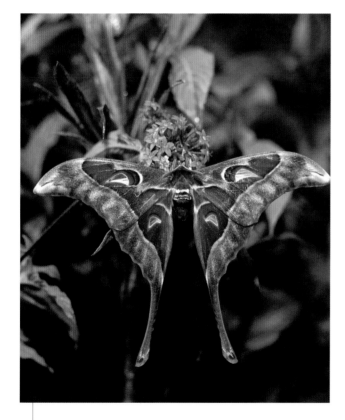

This Hercules moth photographed in Papua, New Guinea, is the largest in the world, with a wing span of about ten inches. The on-camera flash was angled downward, illuminating the top portion of the subject and background but not the bottom, causing uneven exposure. In addition, the background foliage is not compositionally attractive. It's a mess, actually, and does not complement the moth. Moments after I took the shot, the moth took flight and was instantly grabbed by a bird.

🕸 *Mamiya RZ 67 II, 110mm normal lens, 1/125, f/11, Metz 45 flash, Fujichrome Velvia, hand held.*

This is a privately owned rhinoceros in Kenya with a 24-hour armed guard. I was on my way to photograph it when my driver and I had a very serious auto accident — our Land Rover rolled twice at 45 miles per hour. When I finally arrived to take pictures, the sun was already high in the sky. The low angle showing the immense size of the animal is good, but the midday sunlight is too harsh.

🕸 *Mamiya RZ 67 II, 350mm APO telephoto, 1/250, f/8–f/11, Fujichrome Provia, tripod.*

Index